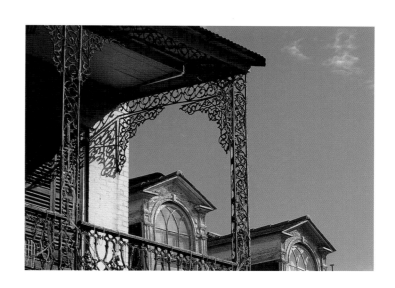

NEW ORLEANS

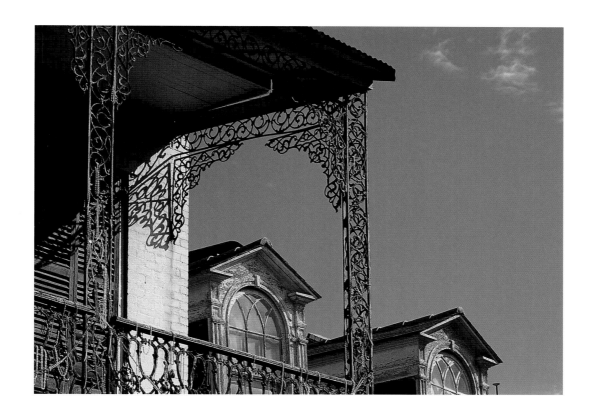

WHITECAP BOOKS
VANCOUVER / TORONTO / NEW YORK

Text by Tanya Lloyd
Edited by Elaine Jones
Photo editing by Tanya Lloyd
Proofread by Lisa Collins
Cover and interior layout by Roberta Batchelor

Printed and bound in Canada

National Library of Canada Cataloguing in Publication Data

Lloyd, Tanya, 1973–
 New Orleans

 (America series)
 ISBN 1-55285-175-3

 1. New Orleans (La.)—Pictorial works. I. Title. II. Series: Lloyd,
Tanya, 1973- America series.
F379.N543L56 2001 976.3'35064'0222 C2001-910270-4

The publisher acknowledges the support of the Canada Council and the Cultural
Services Branch of the Government of British Columbia in making this publication
possible. We acknowledge the financial support of the Government of Canada through
the Book Publishing Industry Development Program for our publishing activities.

**For more information on the America Series and other Whitecap Books
titles, please visit our web site at www.whitecap.ca.**

The story of New Orleans is a complex web of cultures and characters, sovereign kings and soldiers. First the French, then the Spanish, then the newly formed United States influenced the growing city. At the same time, shipbuilders mingled with pirates on the docks, Creoles brushed shoulders—although not always willingly—with Cajuns, and voodoo queens sold their wares while Catholic priests offered masses.

A quick read through the history books brings adventure to light at every turn. The Spanish Inquisition turned up in town at one point, only to be sent home—the governor decided the inquisition was not something to tempt potential immigrants. The Buccaneer, as Jean Lafitte has been called, strutted the streets in the early 1800s. Condemned as a pirate by the United States government, Lafitte nonetheless fought with President Andrew Jackson against the British. He received a pardon, only to be once more accused of piracy after an attack on an American ship.

If it all seems a maze of contradictions, then you've discovered the true character of New Orleans, where the French Quarter is an enclave of Spanish architecture, where there is a Piazza d'Italia and a Spanish Plaza, where a wedding cake can be a mansion and costumes aren't just for Halloween.

In fact, the culmination of all this convivial confusion is the annual Mardi Gras celebration. Parades wind their way throughout the city, party-goers wear their most outlandish outfits, men masquerade as women, and the main theme is indulgence. But is the city's lively atmosphere a result of the celebration, or does the celebration stem from the vitality of the city? The vivid photos you'll find within these pages only begin to offer an answer.

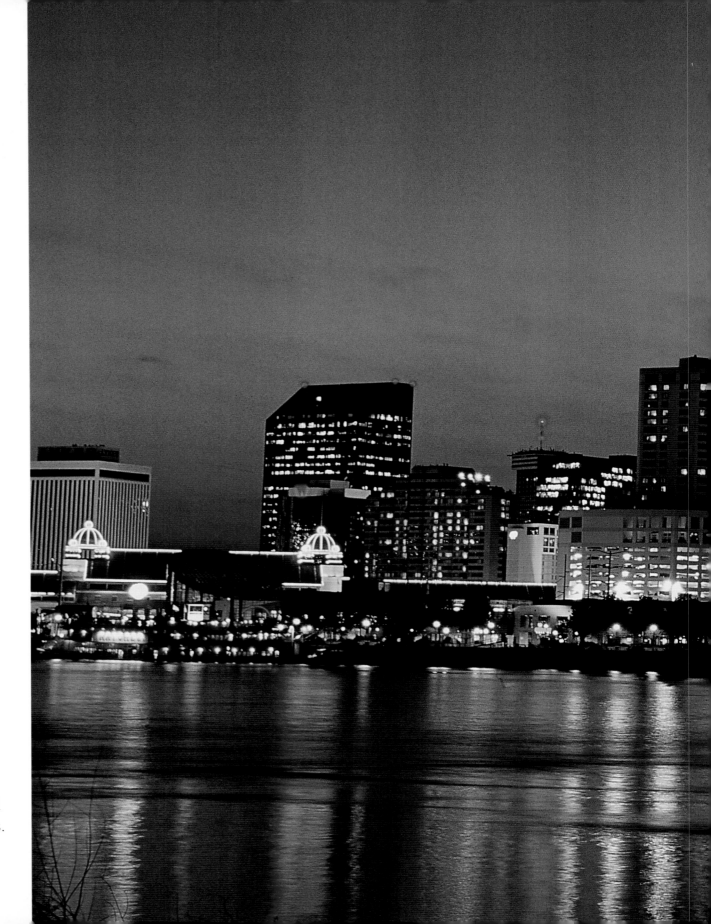

Governed by France until 1763, New Orleans was under Spanish rule for 40 years until Napoleon regained the city for France, and then sold it to the United States.

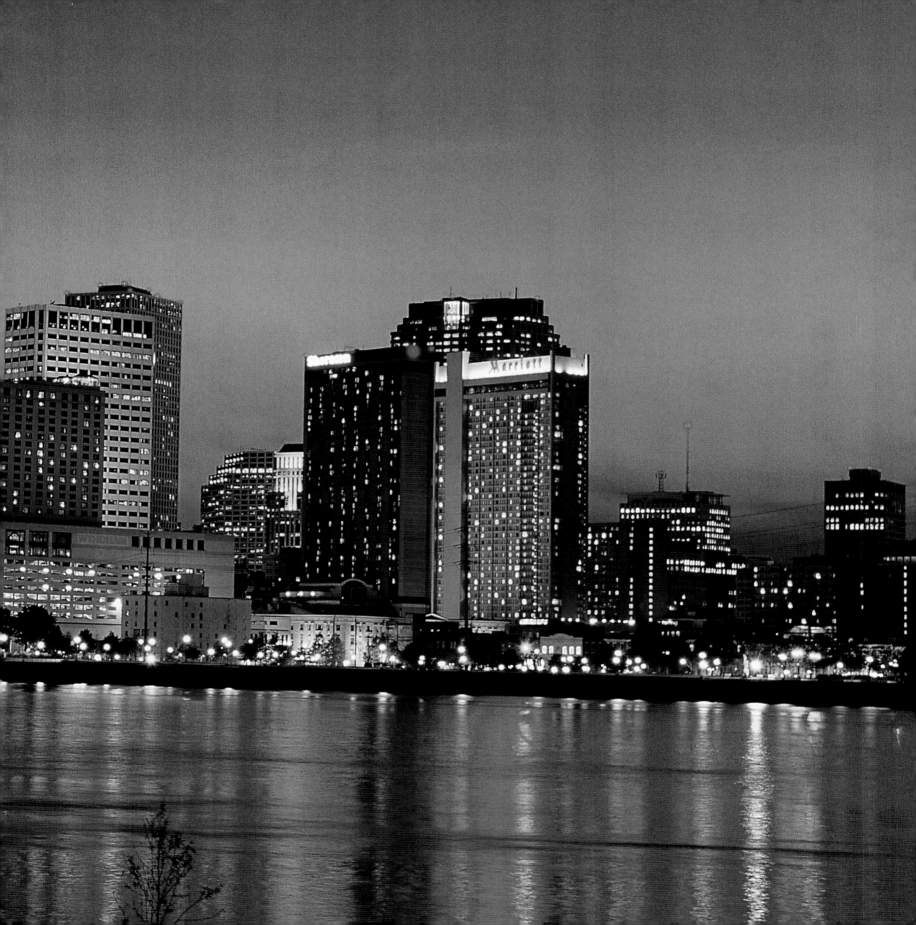

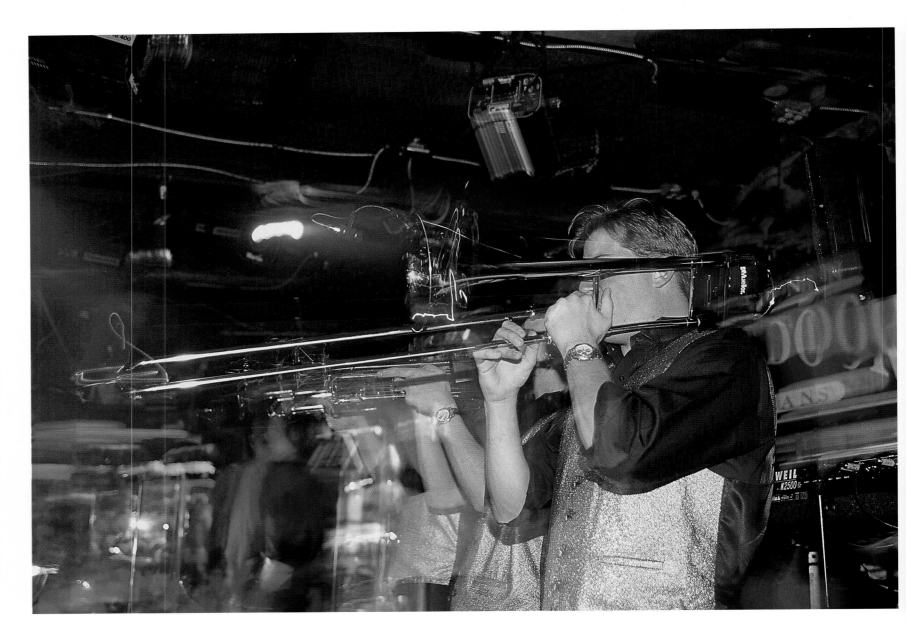

Bourbon Street was named for one of France's ruling families. Along with France, Spain, and Naples, the Bourbons ruled New Orleans for parts of the eighteenth century.

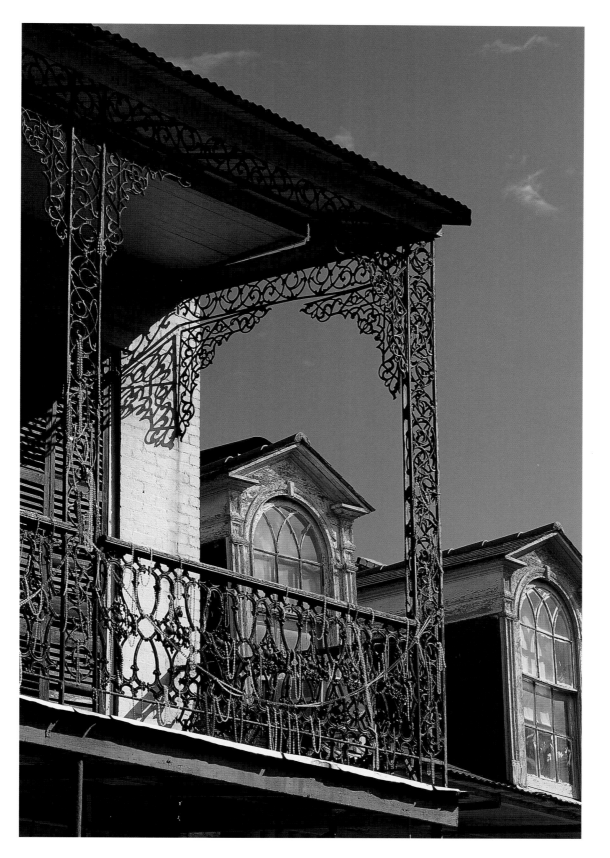

The French Quarter, also known as Vieux Carré, is the oldest part of the city and remains the heart of New Orleans culture. Ironically, most of the architecture in the neighborhood is Spanish; the original French buildings were destroyed by fire.

9

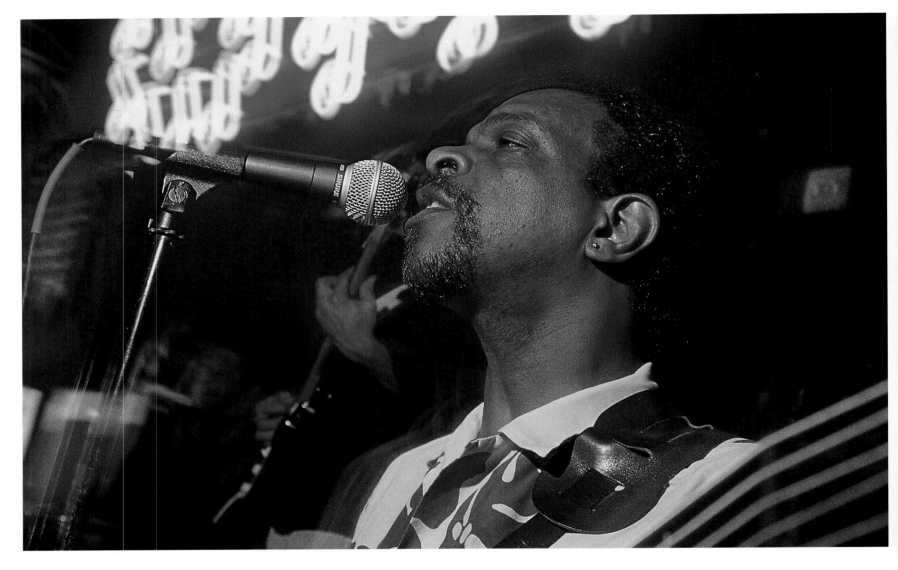

Louisiana's largest city is home to a thriving music scene, with jazz performers drawing crowds to the French Quarter every night of the week.

Now part of a nation-wide network, Dan Ackroyd's famous House of Blues draws crowds with live music and Creole cooking —New Orleans–style seafood gumbo, catfish nuggets, classic po-boys, and more.

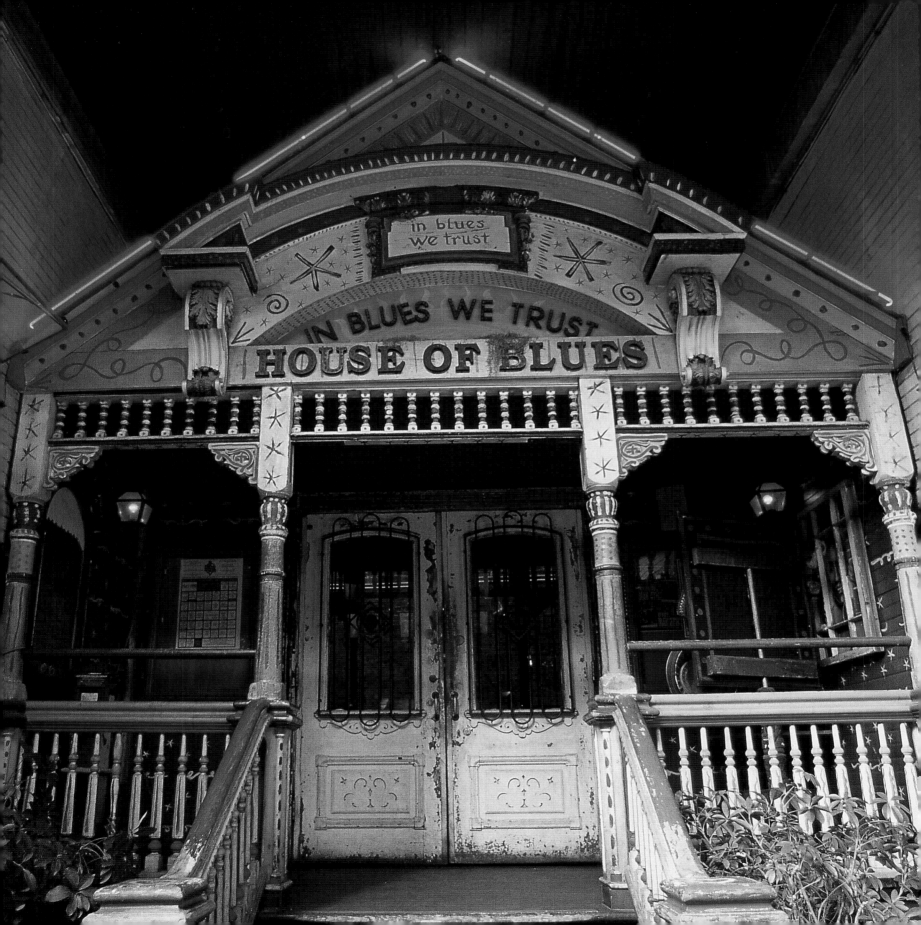

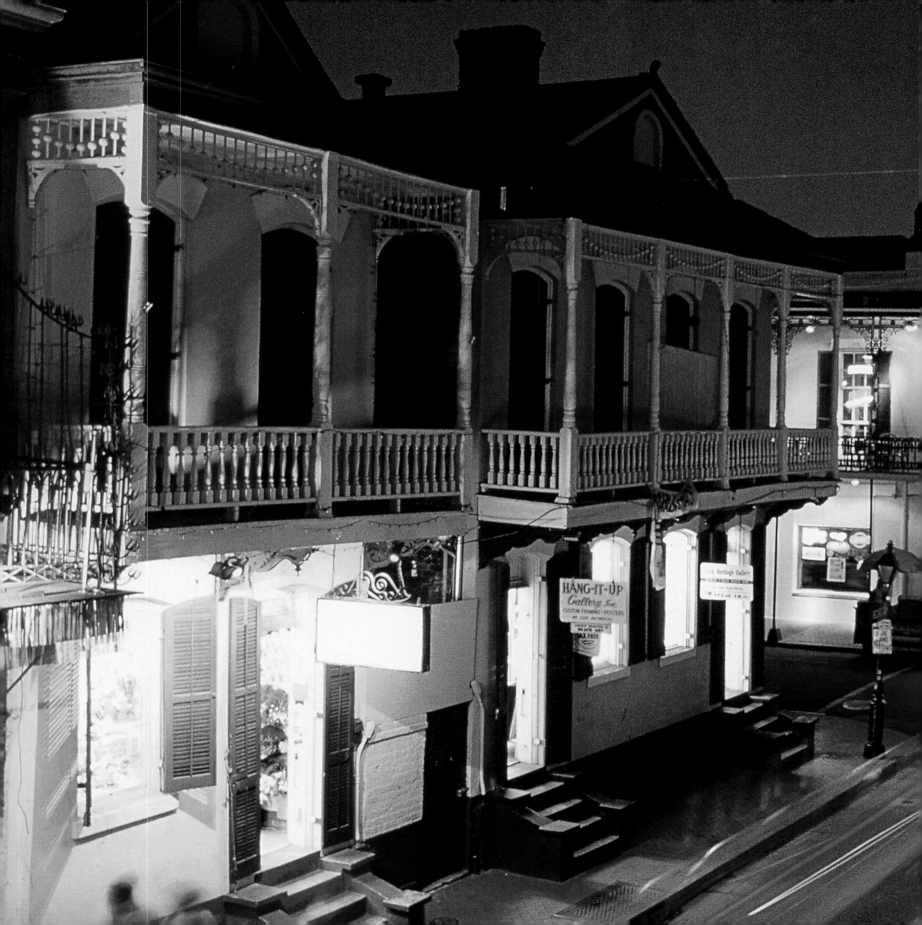

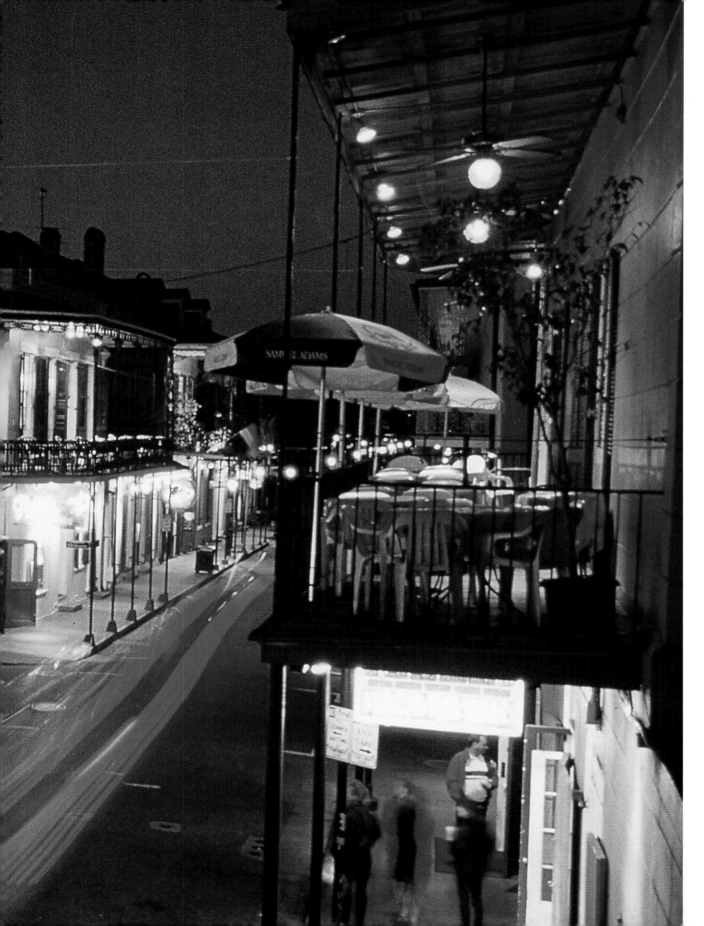

Myriad cultures mixed in early New Orleans society. The Creole set was the upper crust, of French and Spanish descent. The Cajun population—descendants of the Acadians who fled British rule in Canada—were another major influence on the city.

13

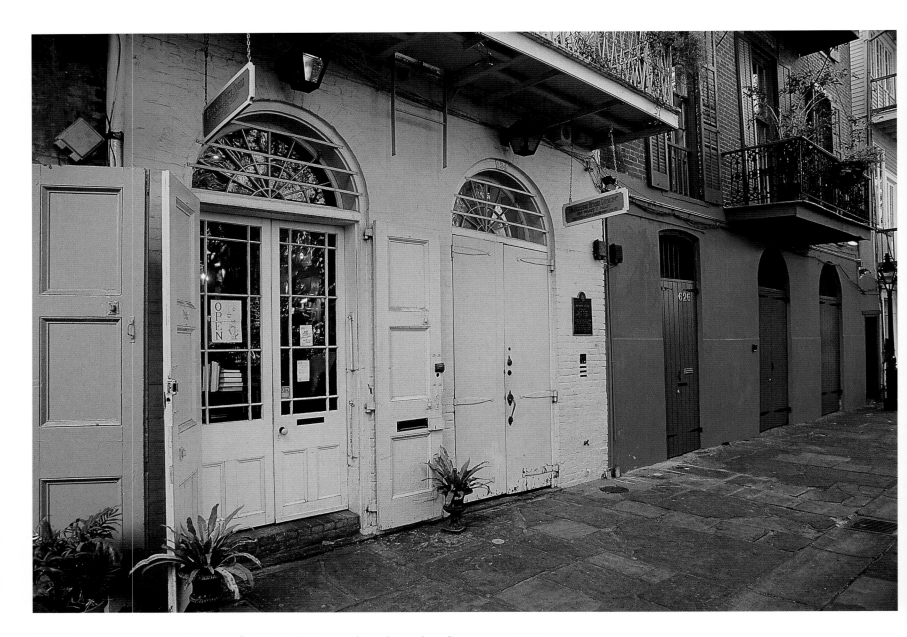

William Faulkner, winner of a Nobel Prize, lived in this home at 624 Pirate's Alley while he wrote his first novel, *Soldier's Pay*. Faulkner House Books now sells works of literature from a shop on the ground floor.

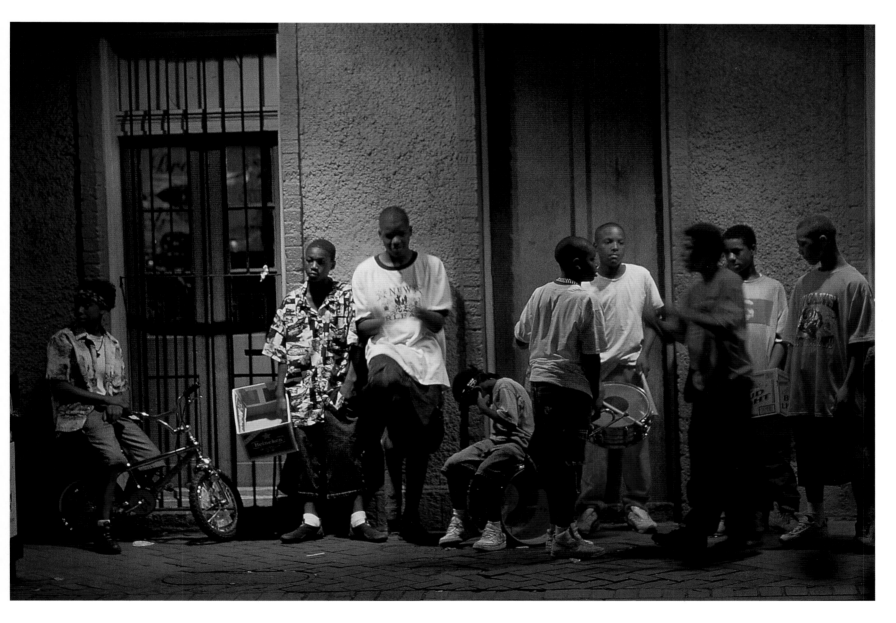

New Orleans youth linger outside on a summer evening watching costumed party-goers make their way to Mardi Gras events.

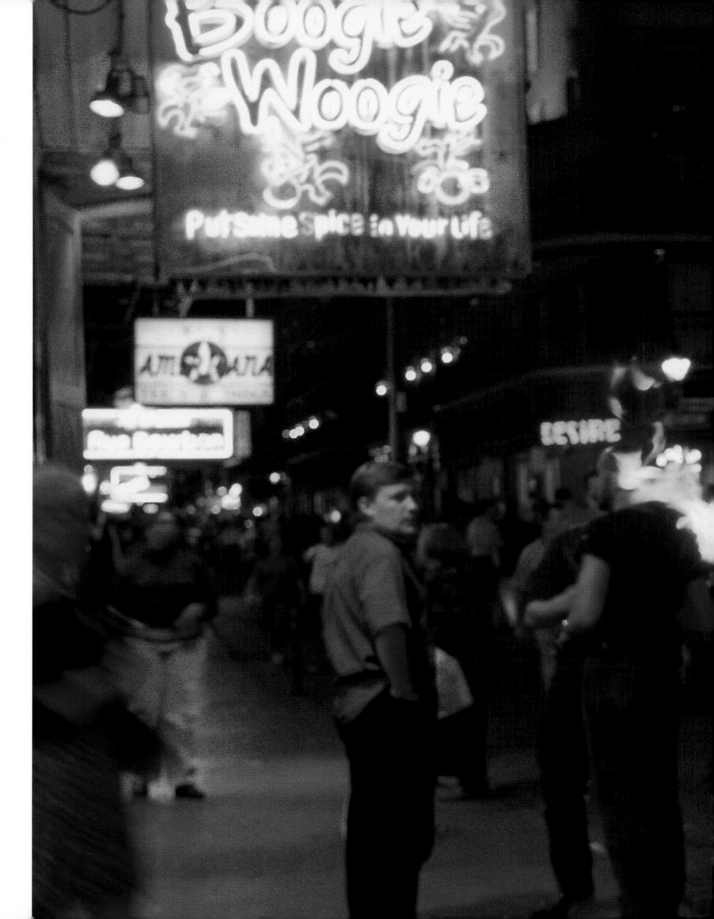

A fire-eater awes crowds in the French Quarter. From musicians and mimes to acrobats and magicians, each corner of the city provides entertainment.

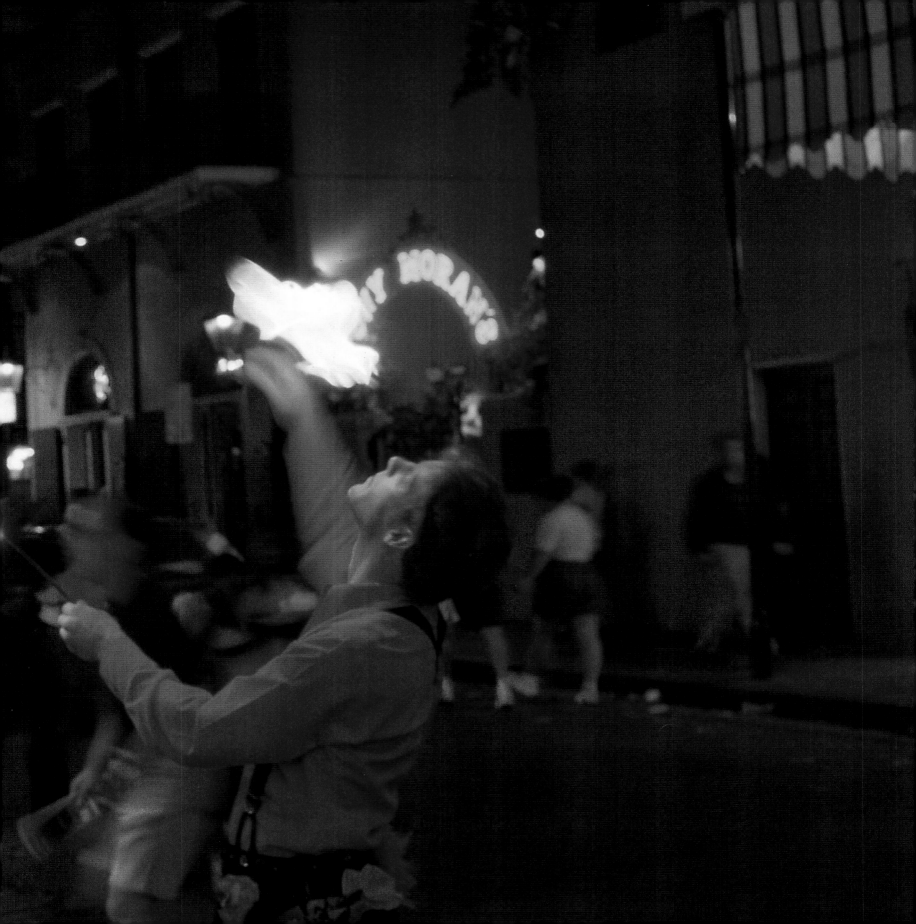

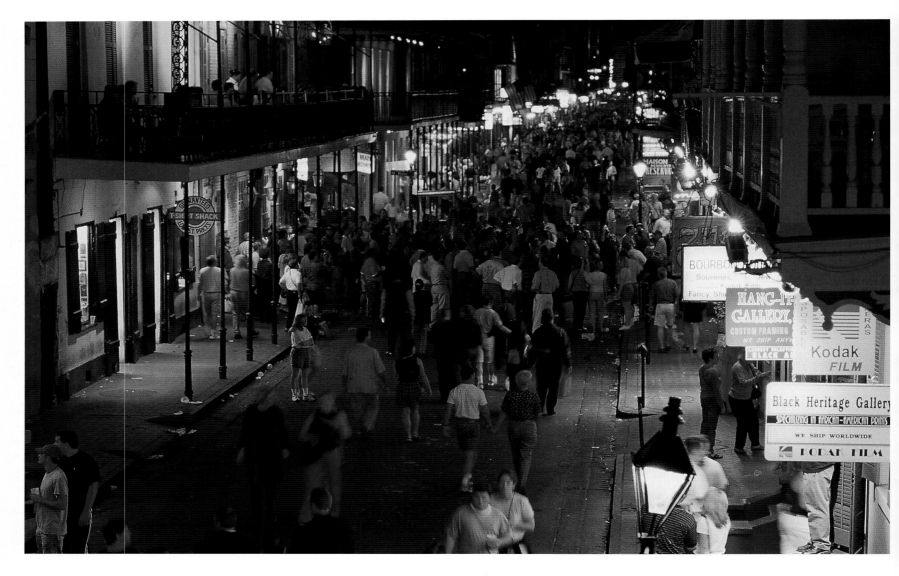

The streets of New Orleans come to life as the sun sets. Many residents and visitors choose to simply stroll the streets of the French Quarter, watching the crowds and catching strains of music from nearby clubs.

The Hermann-Grima House was created for merchant Samuel Hermann in 1831, then sold to Judge Felix Grima in 1844. Furnished with silk draperies, woven wool carpets, and family portraits, the home offers an authentic look at New Orleans' wealthy families in the nineteenth century.

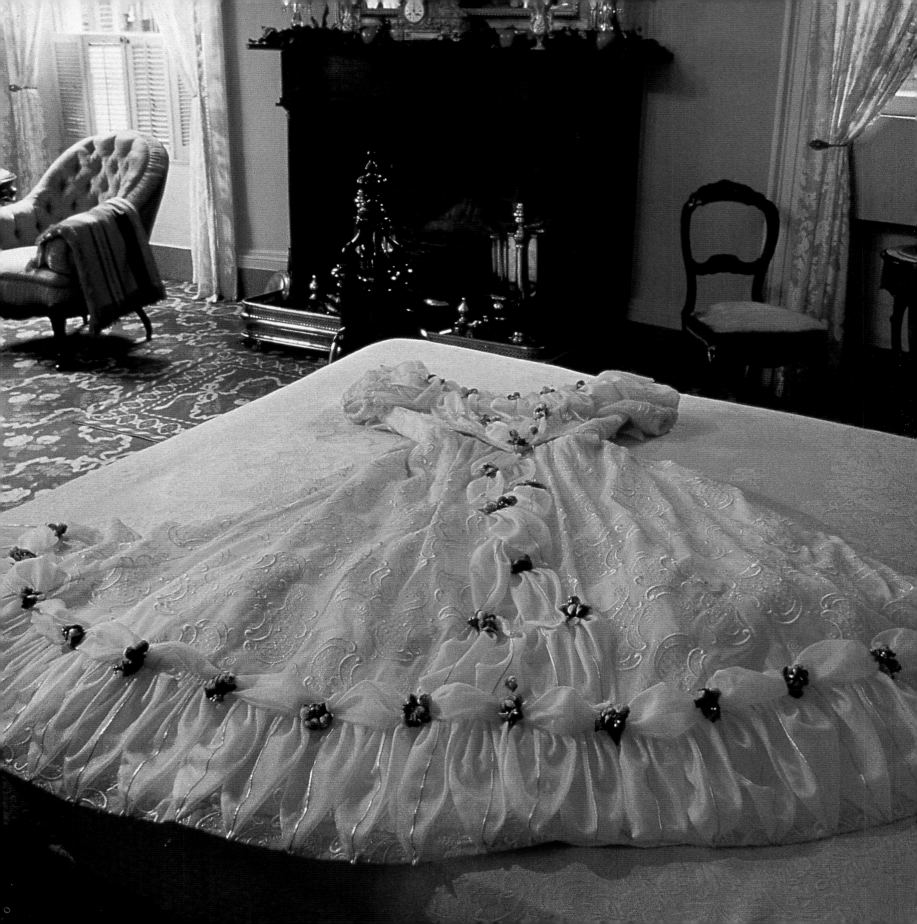

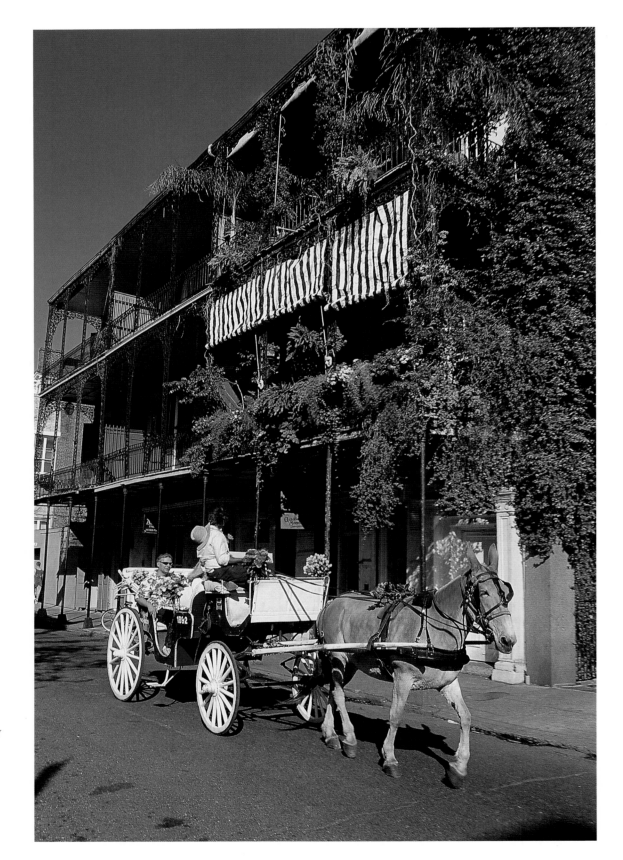

In 1722, France moved its center of rule in America from Biloxi, Mississippi, to New Orleans. Engineer Adrien de Pauger was commissioned to design the new city. His legacy remains on Bourbon Street and other famous city thoroughfares.

20

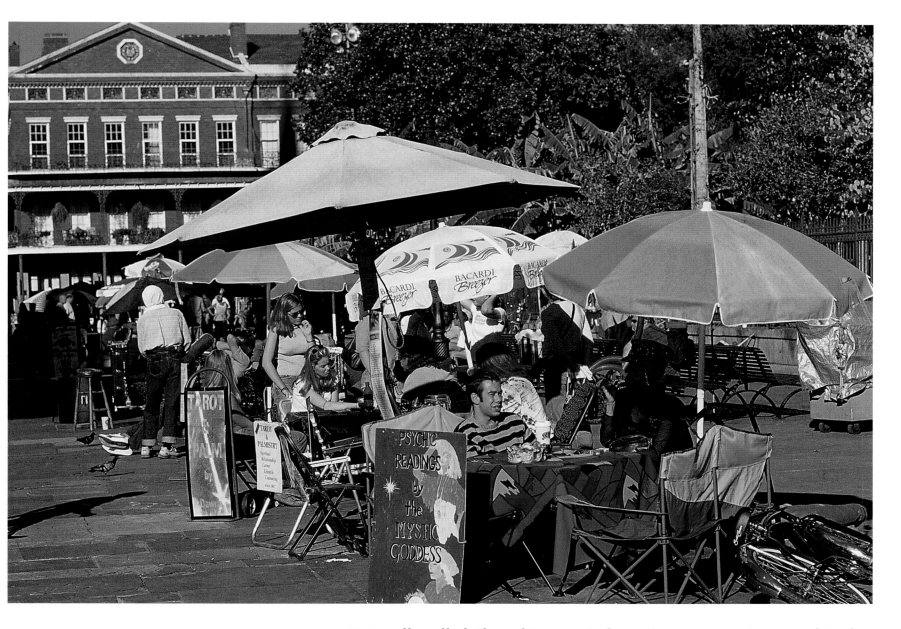

Originally called Place d'Armes, Jackson Square was rejuvenated in the mid-1800s and renamed for General Andrew Jackson, a hero from the War of 1812. Now filled with lush gardens and quiet walks, this was the site of military parades and public meetings in early colonial days.

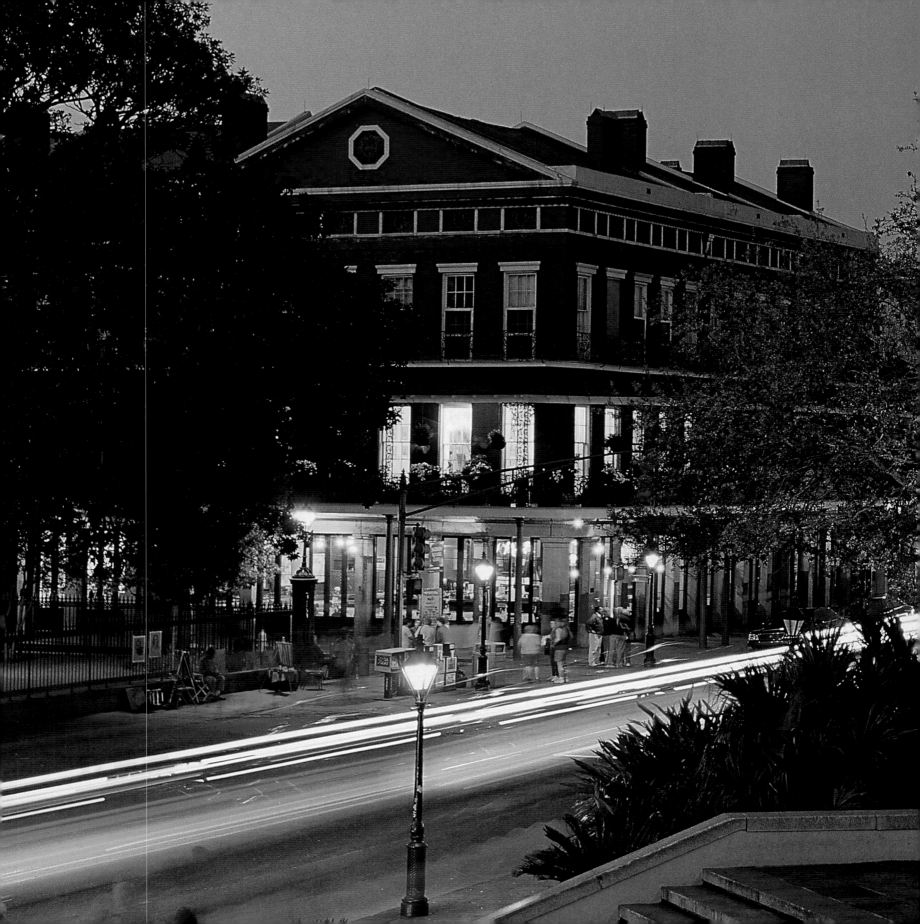

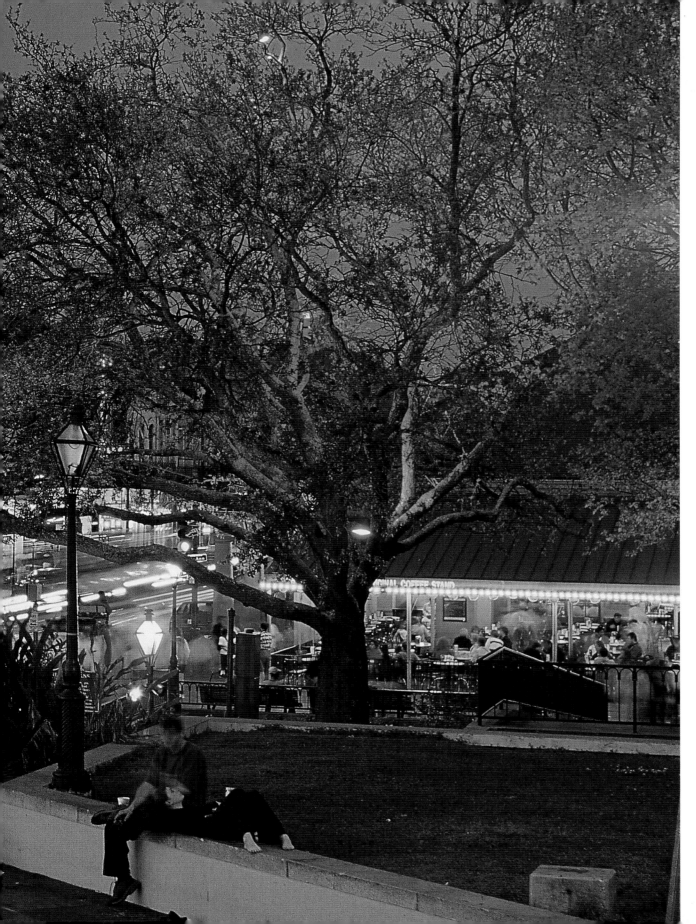

The Baroness Micaela Almonester de Pontalba built a row of red brick townhouses facing Jackson Square in 1849 and 1850. The Louisiana State Museum has preserved an example of these fashionable middle-class homes as 1850 House, now open to the public.

23

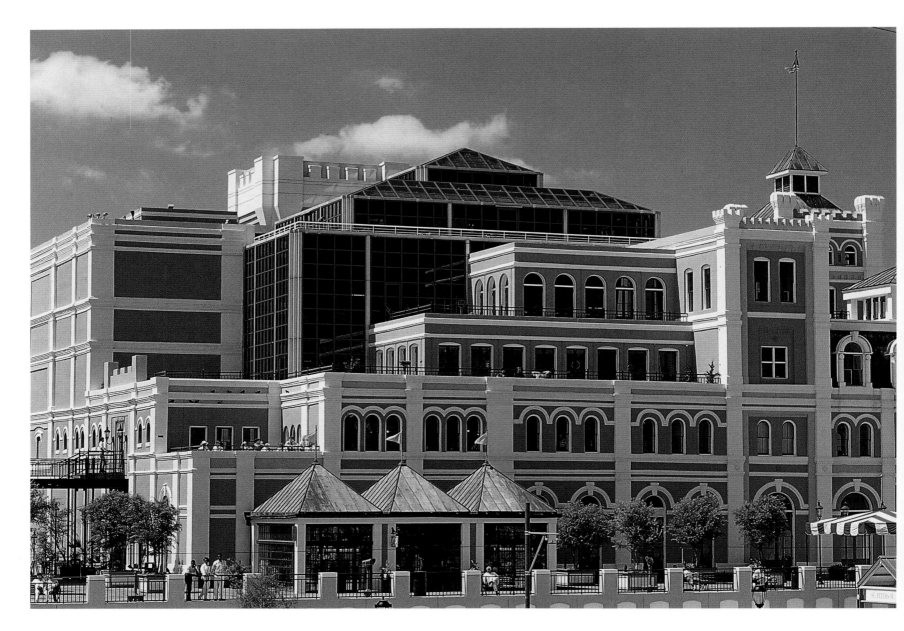

Once the home of JAX beer, the Jackson Brewery is now a lively shopping center, complete with attractions, gift shops, and restaurants.

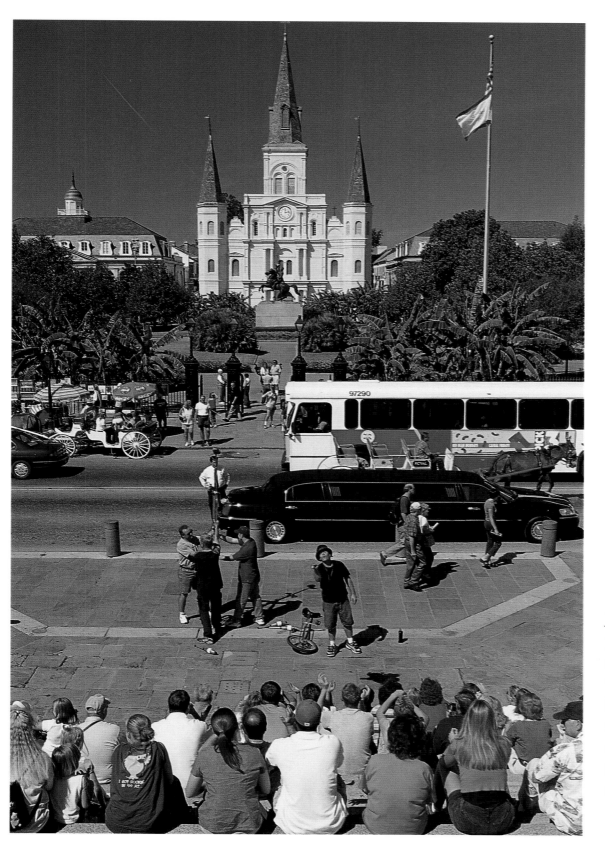

Jackson Square is the perfect place for vendors to display their wares, appropriating iron fencing as display racks. Street performers and musicians wander through the crowds on summer days.

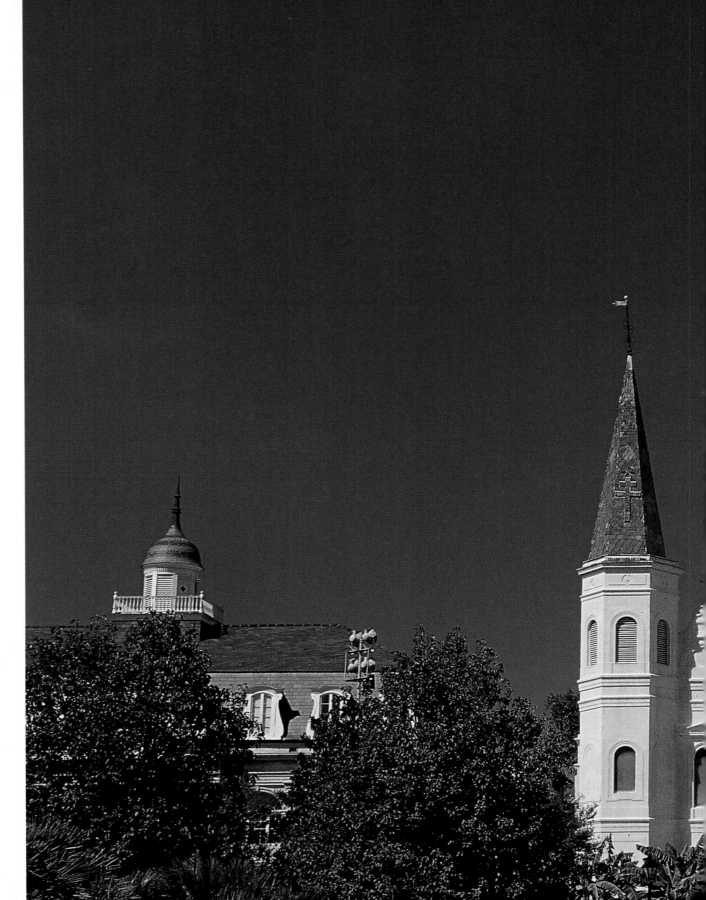

The St. Louis Cathedral is the oldest on the continent, built in 1720. It is said to be inhabited by the ghost of Père Dagobert, a beloved priest who arrived in the city in 1745.

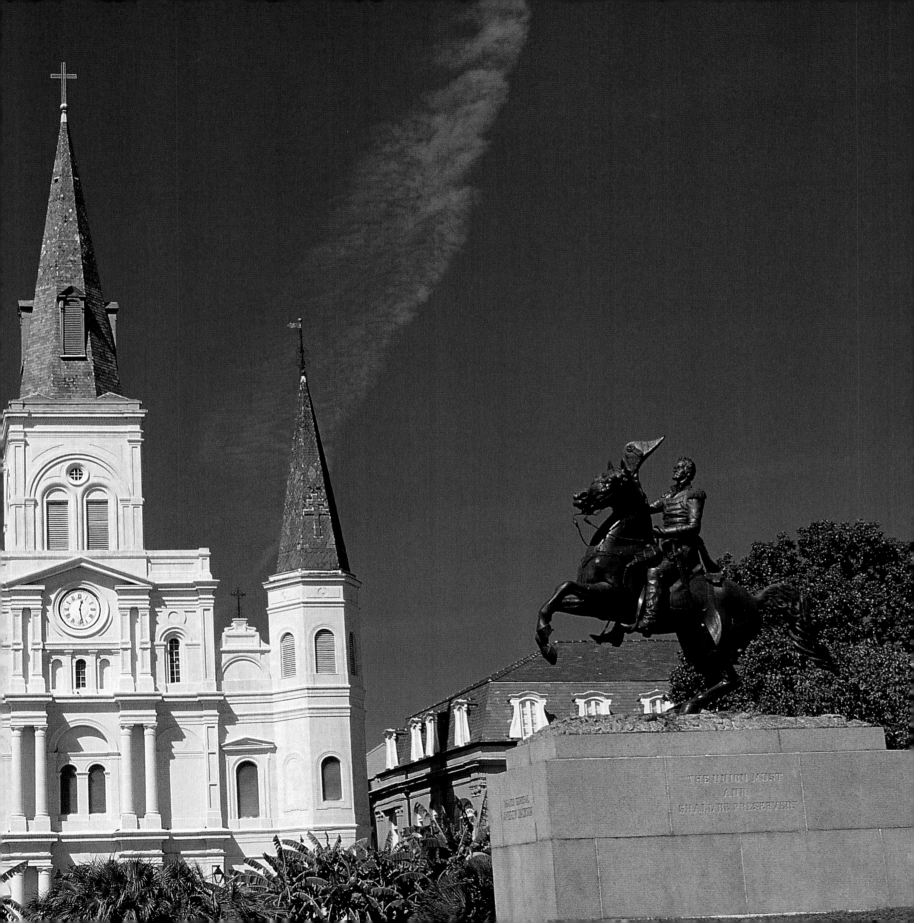

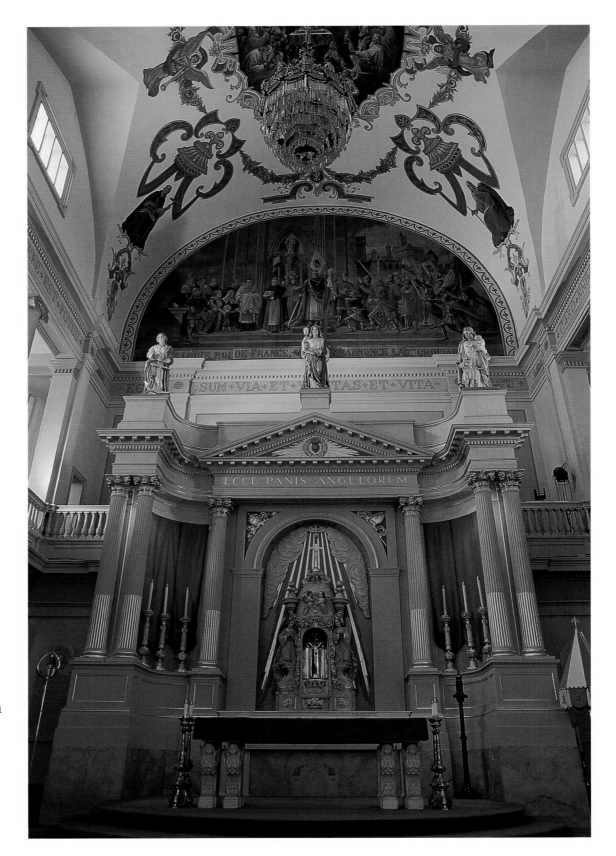

Buried under one of the altars of St. Louis Cathedral lies Don Andres Almonaster Roxas, who rebuilt the church after the first structure was destroyed by fire in 1788. The cathedral was partly rebuilt again in 1850.

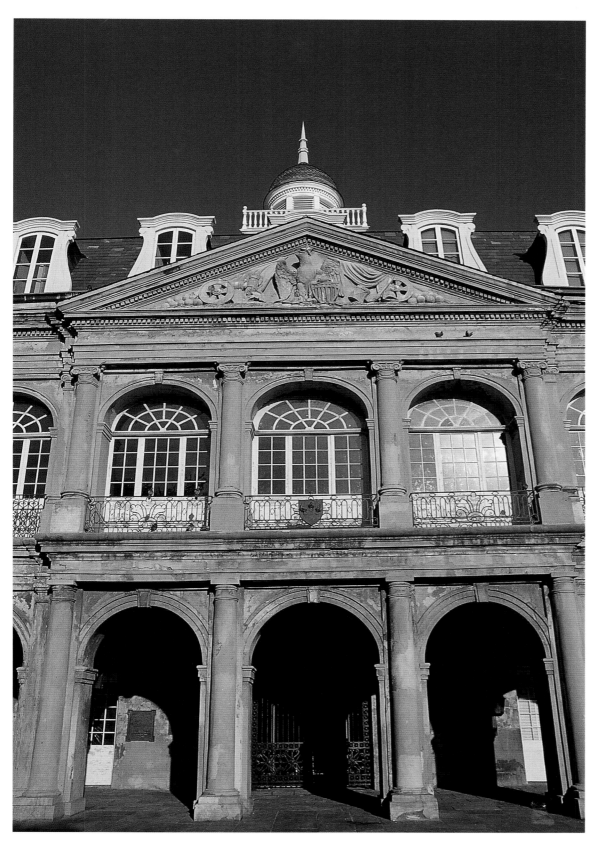

Built in 1799, the Cabildo was the seat of Spanish government in New Orleans. Representatives from France and the United States met here in 1803 to sign the Louisiana Purchase, transferring control of the territory into American hands. The Cabildo is a national historic landmark.

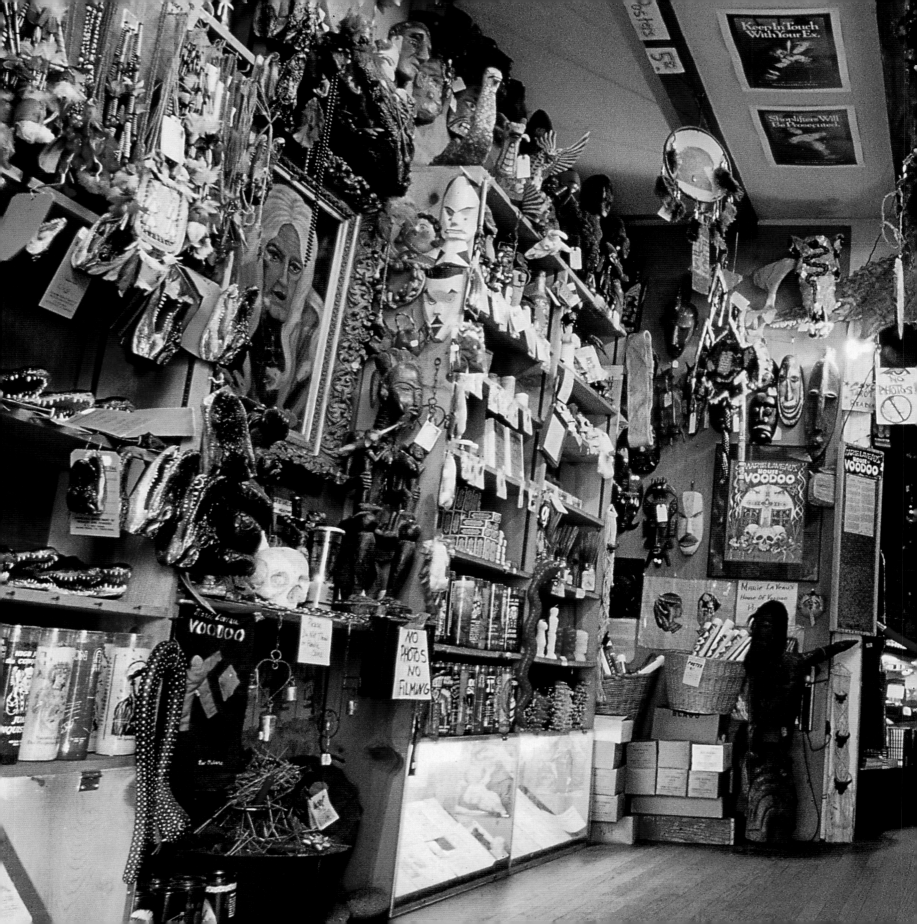

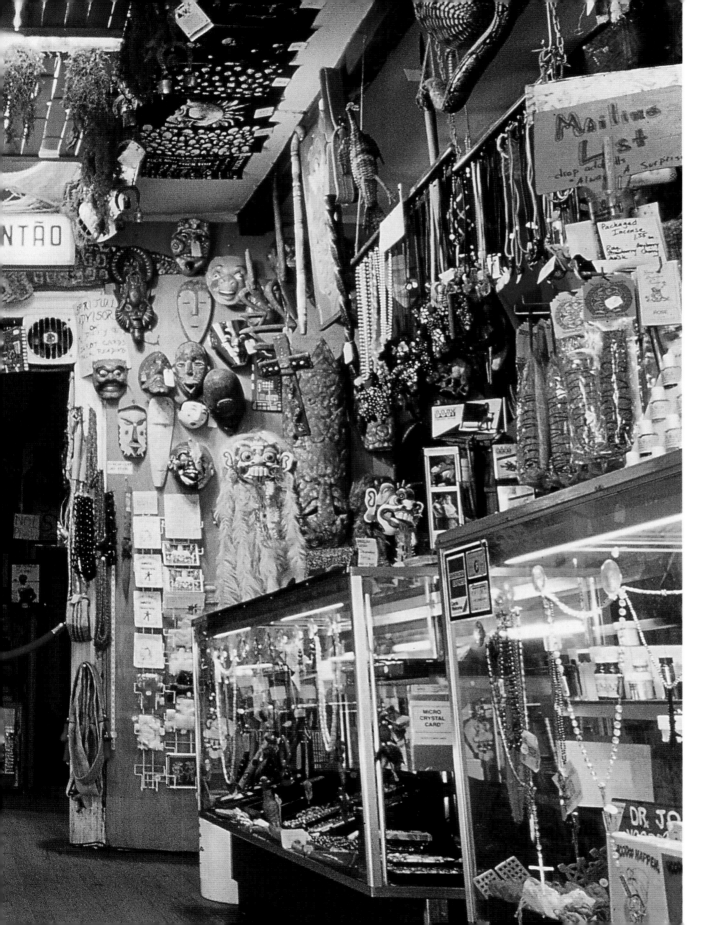

Brought to America with the slaves who arrived from West Africa via Haiti, voodoo has become a famous part of New Orleans culture. In its purest form, voodoo is a practice of understanding and serving the spirits.

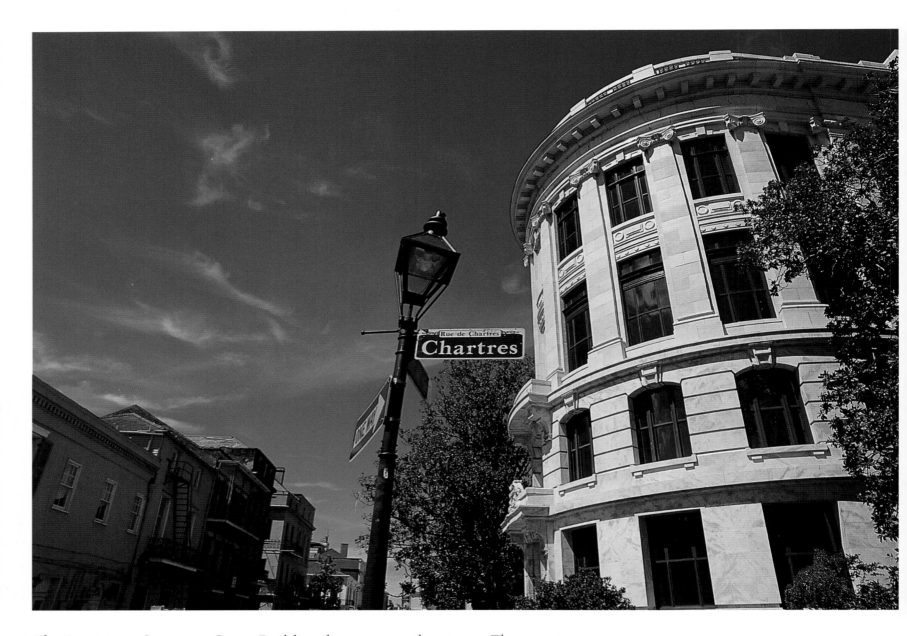

The Louisiana Supreme Court Building looms over the street. The courts in New Orleans were overseen by France and Spain until 1803, when the territory was bought by the United States. President Thomas Jefferson named W.C.C. Claiborne the first American judicial officer in the city.

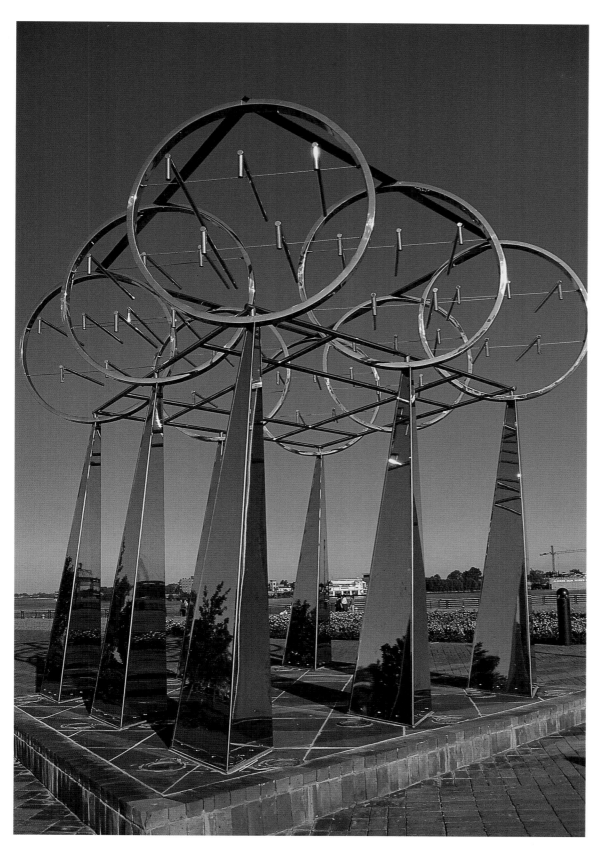

Woldenberg Park is a quiet retreat along the banks of the Mississippi. The city's parks range from manicured lawns and decorative flower beds to swamp preserves, lagoons, zoological gardens, and theme parks.

33

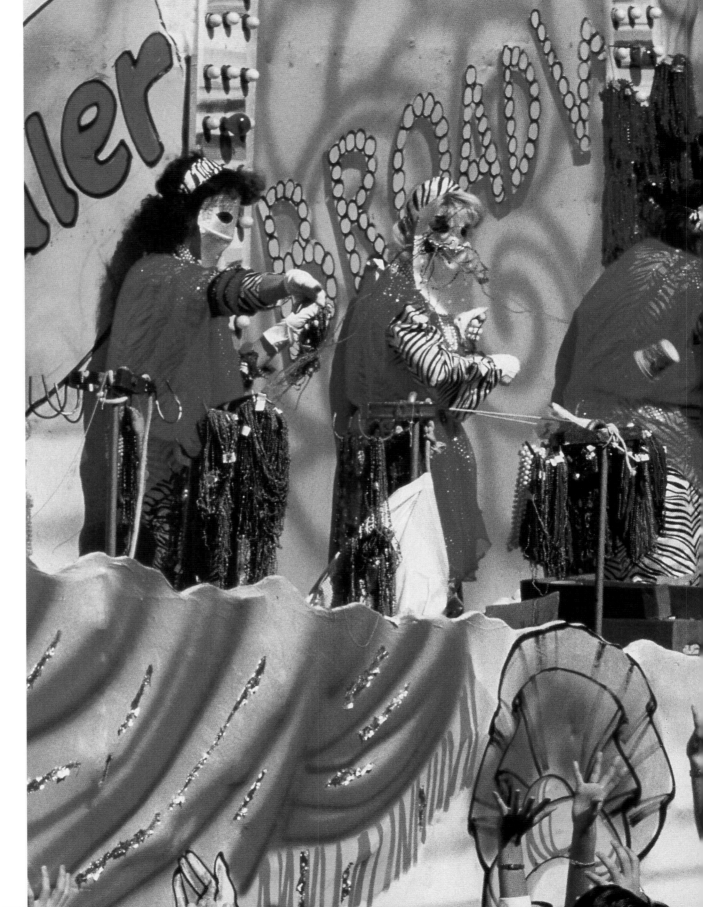

Historians believe that Mardi Gras began in New Orleans when a group of students returned from Paris in 1827. There, they had witnessed Carnival, a Christian celebration in which people donned masks and joined in mass revelry before the fasts and penitence of Lent.

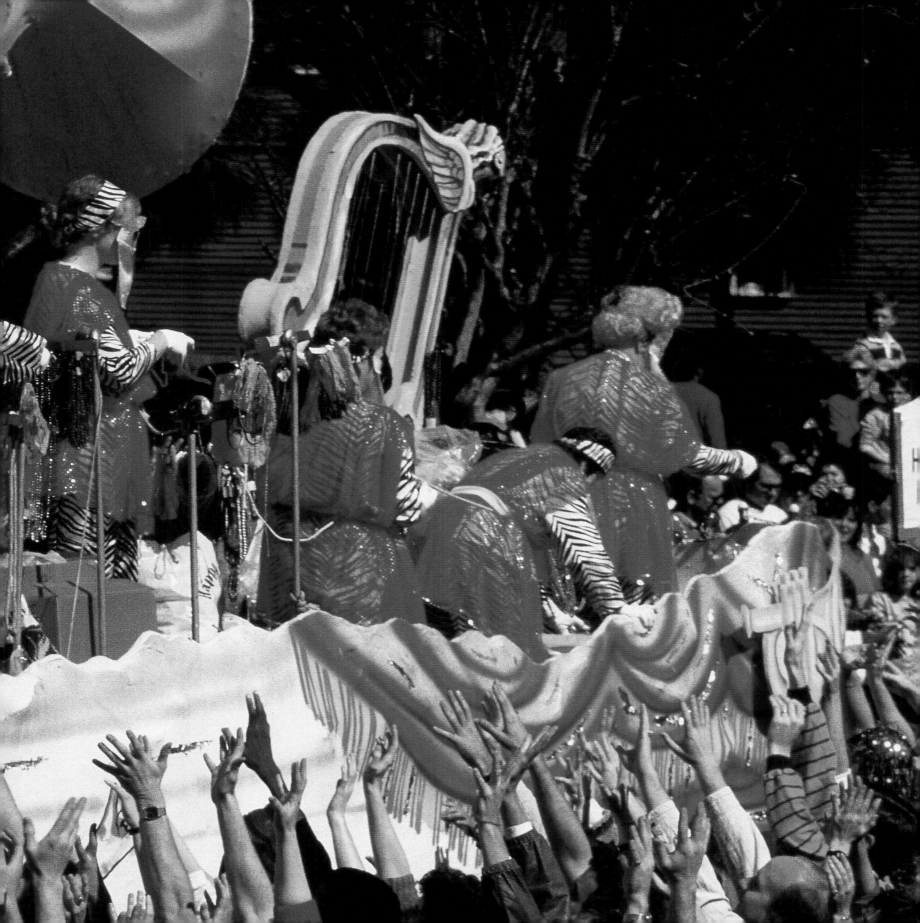

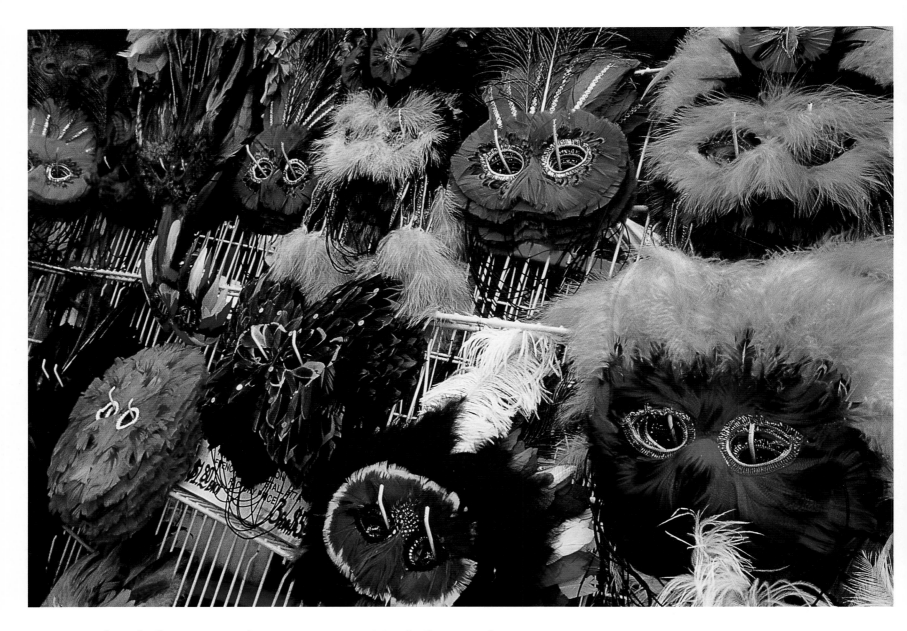

Forty-six days before Easter, the city erupts in Mardi Gras revelry, famous around the world. Carnival, the period between January 6 and Mardi Gras, is one celebration after another, from elaborate balls to raucous parades.

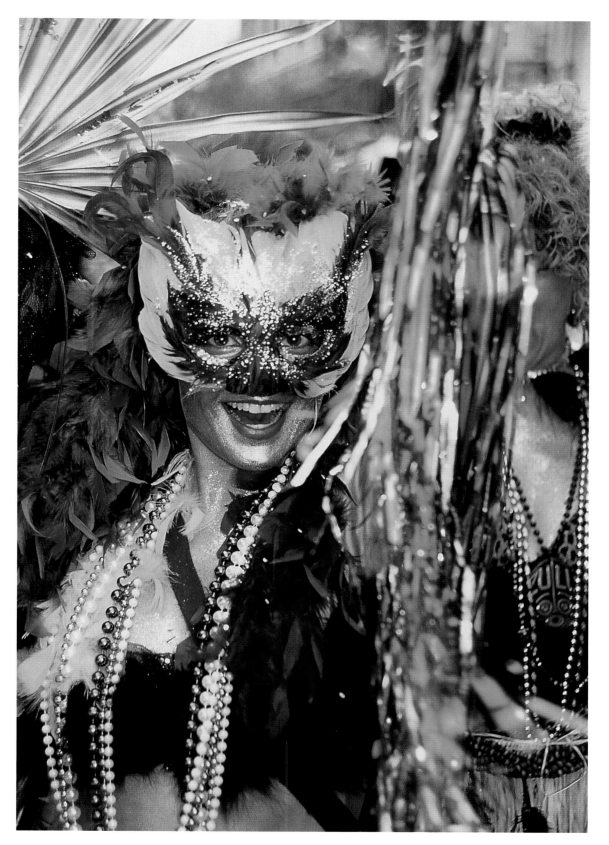

Almost 60 parades wind through the streets in the 12 days before Mardi Gras. Most feature 18 floats, led by a king and queen. A single procession may involve more than 3,000 performers.

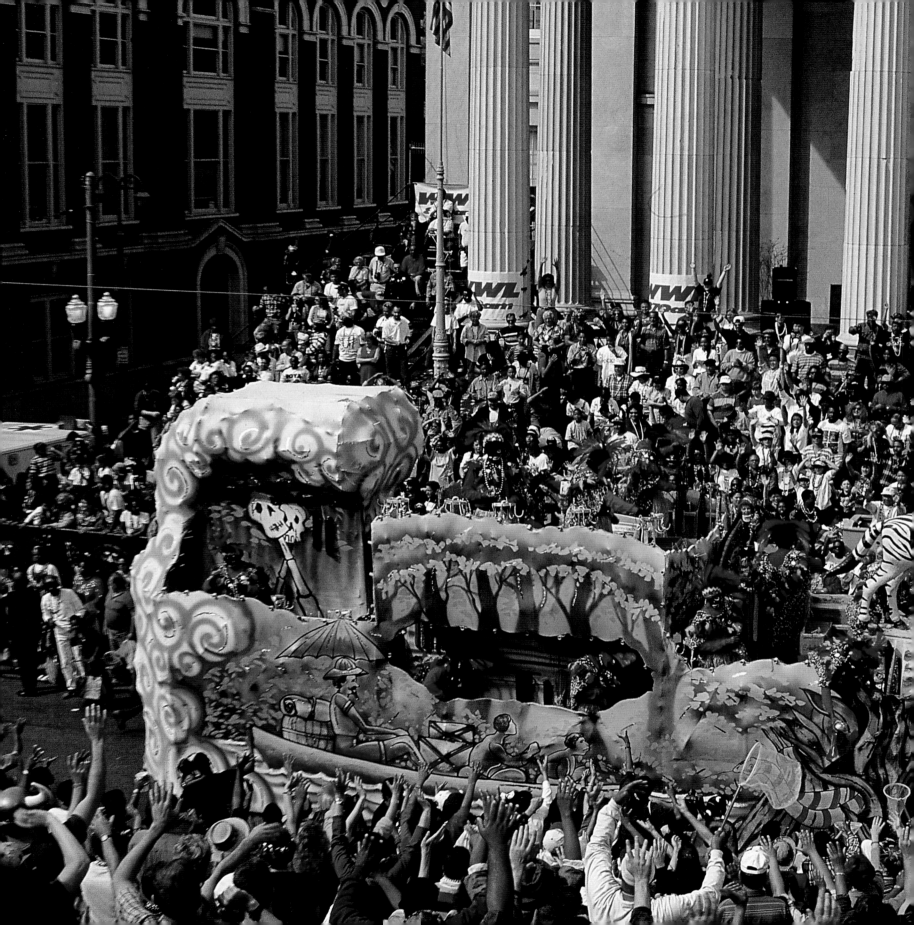

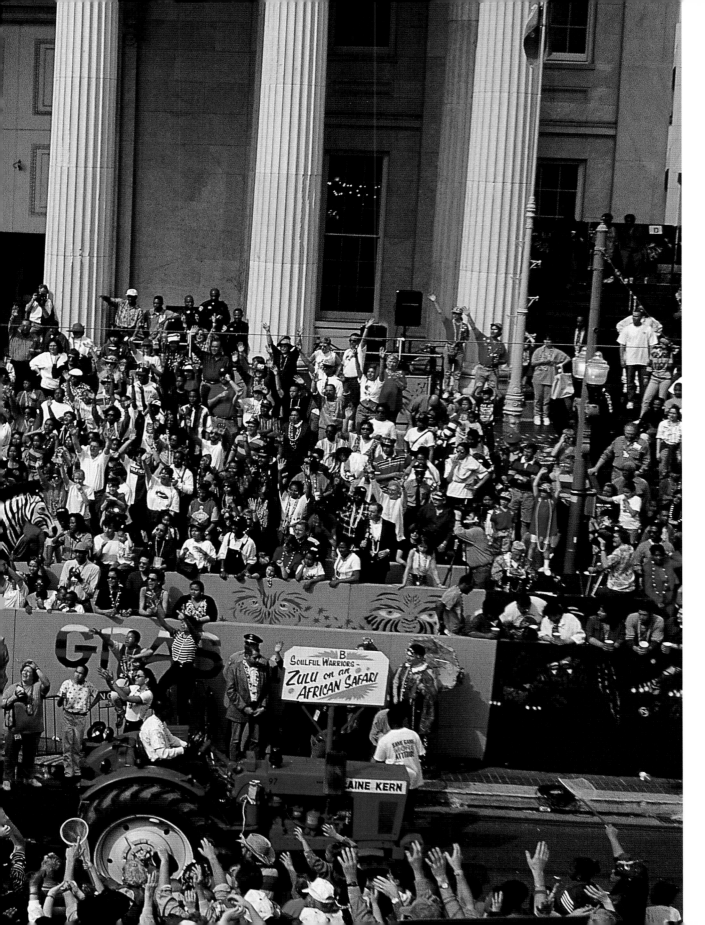

It takes months to create the floats and costumes that make the parades famous. About three-quarters of the floats are created by a single company —Blaine Kern's Mardi Gras World.

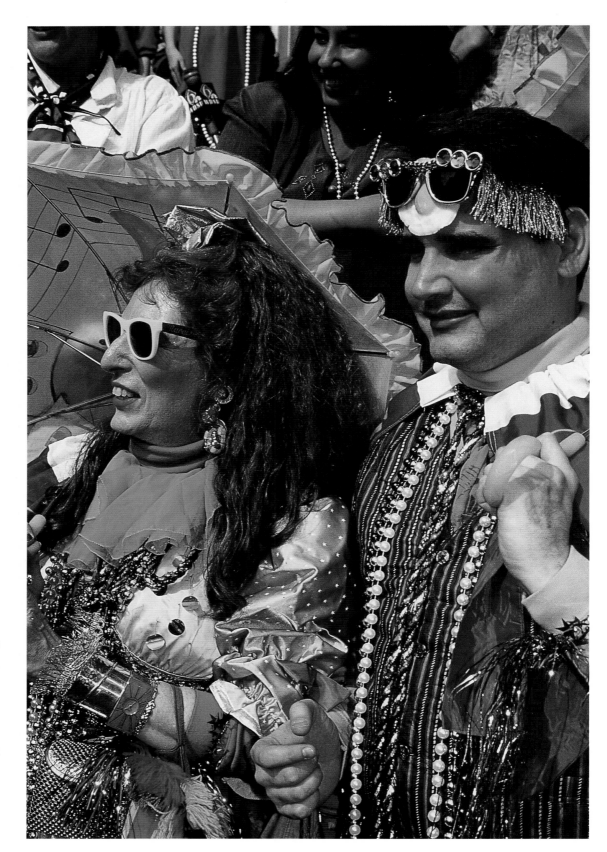

Even before Carnival developed in Europe, pagan priests greeted the season dressed as women, offering themselves to the party-goers. The church stopped the practice in the Middle Ages, but the costume theme has survived as part of Mardi Gras.

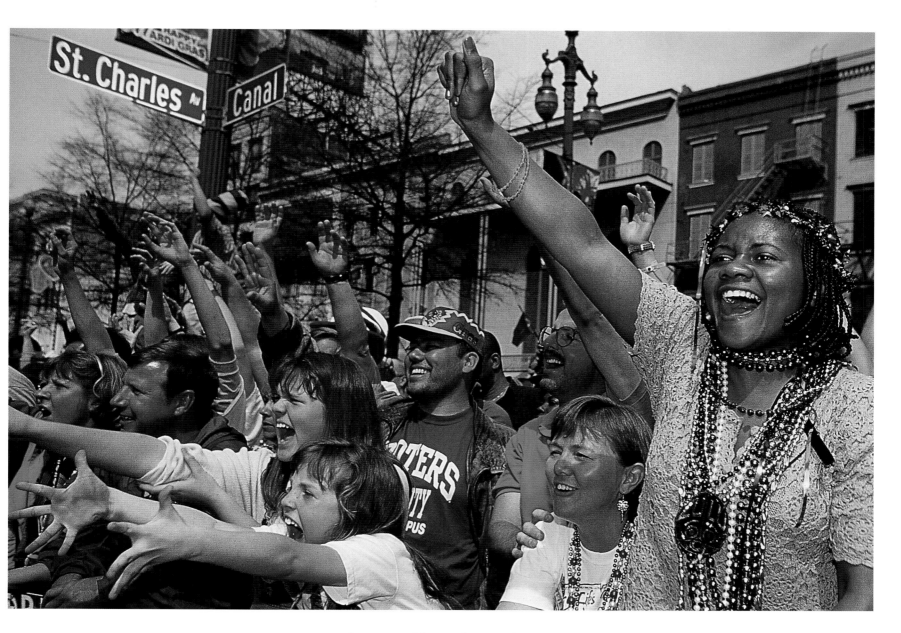

The crowd begs for trinkets—known as "throws" in Mardi Gras lingo—during a parade. Performers on the floats might throw beads, cups, and toys to the spectators.

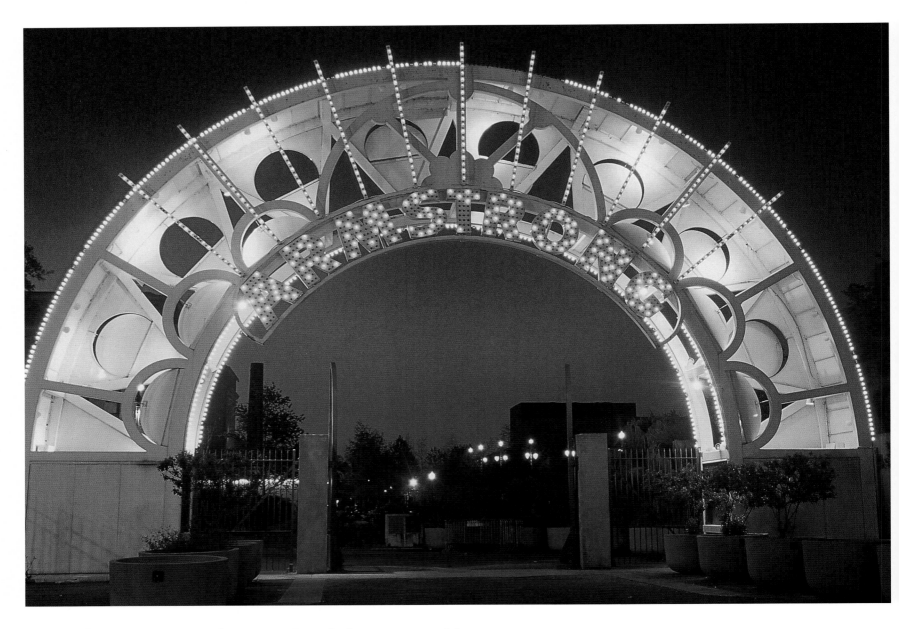

New Orleans Jazz National Historical Park, known to residents as Louis Armstrong Park, includes an auditorium, a theater, and a public square. Officially named in 1994, the park is designed to preserve and interpret the origins and growth of jazz in the city.

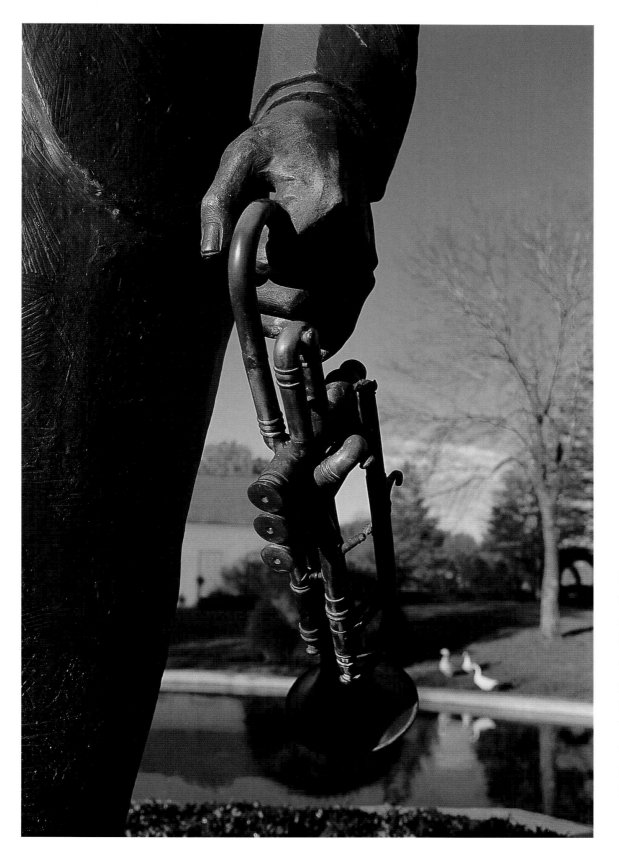

Louis Armstrong grew up in one of the poorest districts in New Orleans, singing on street corners to help support his family. He bought his first horn at age seven and went on to help create a new musical genre known as jazz.

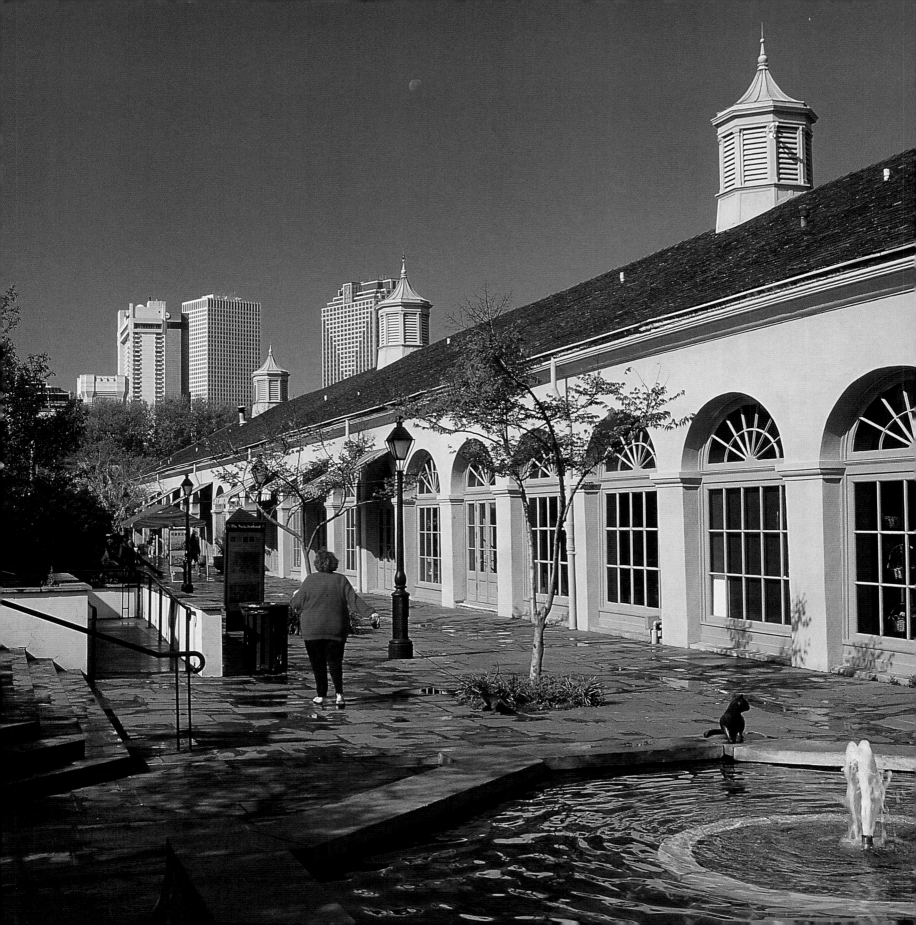

A stroll down Royal Street leads past art galleries featuring local and international artists. There are more than 100 galleries in the city—about 30 on this street alone. They range from small contemporary displays to stately buildings filled with traditional European works.

The oldest buildings in the French Market date from 1813, and the site itself was once a Choctaw trading post. Today, the long sheds draw visitors inside for a taste of real sugar cane, a still-warm pastry, or a bright display of fresh produce.

Built in the early
1800s, this town-
house may have been
the first four-story
building in New
Orleans. It is now
home to the Royal
Café, a favorite stop
for weary sightseers.

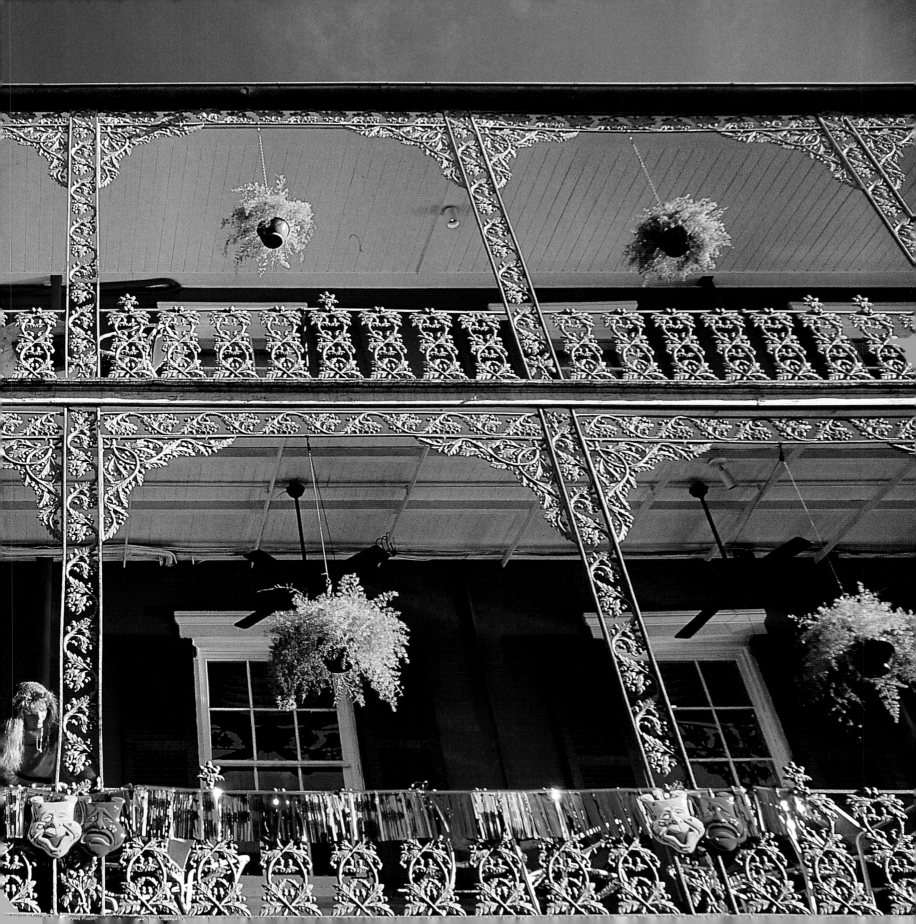

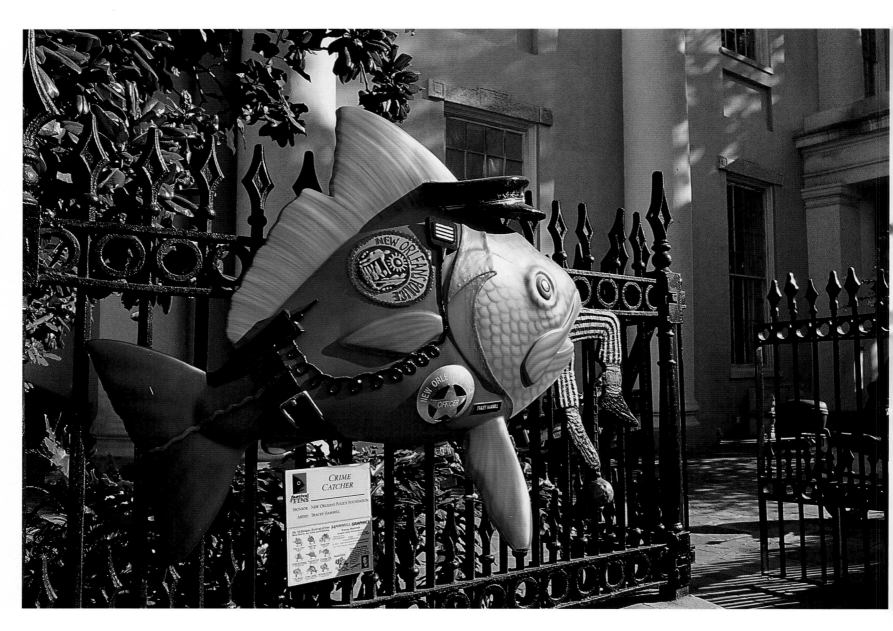

CRIME
CATCHER

Festival
FINS

SPONSOR: NEW ORLEANS POLICE FOUNDATION

ARTIST: TRACEY HAMMILL

HAMMILL GRAPHICS

A whimsical sculpture captures the eye outside the police station on
Royal Street. Works by more than 100 artists decorate sidewalks
and plazas around the city, thanks to a bylaw that requires many
construction firms to set aside funds for public art.

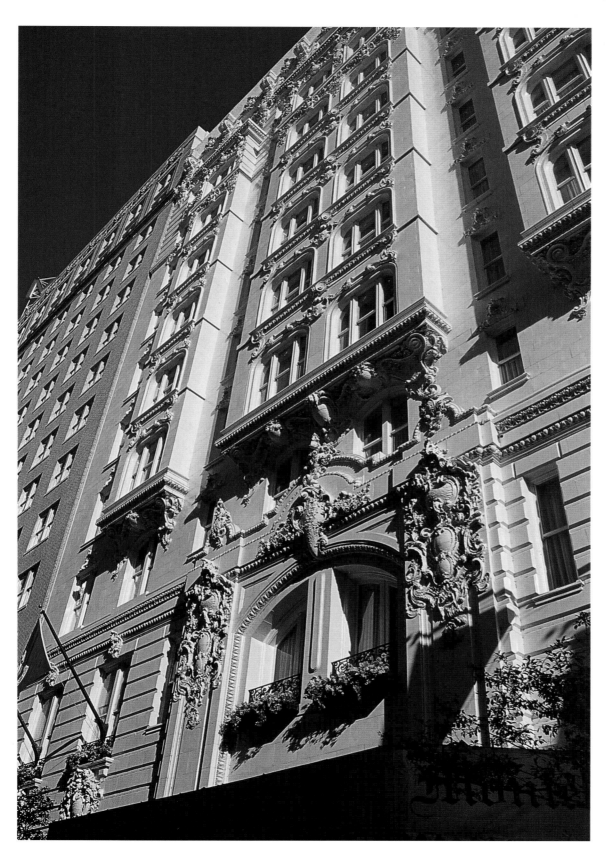

Founded in 1886, the Hotel Monteleone is now a national historic landmark. Six hundred guest rooms offer first-class accommodations where such icons as Tennessee Williams, William Faulkner, and Truman Capote once slept.

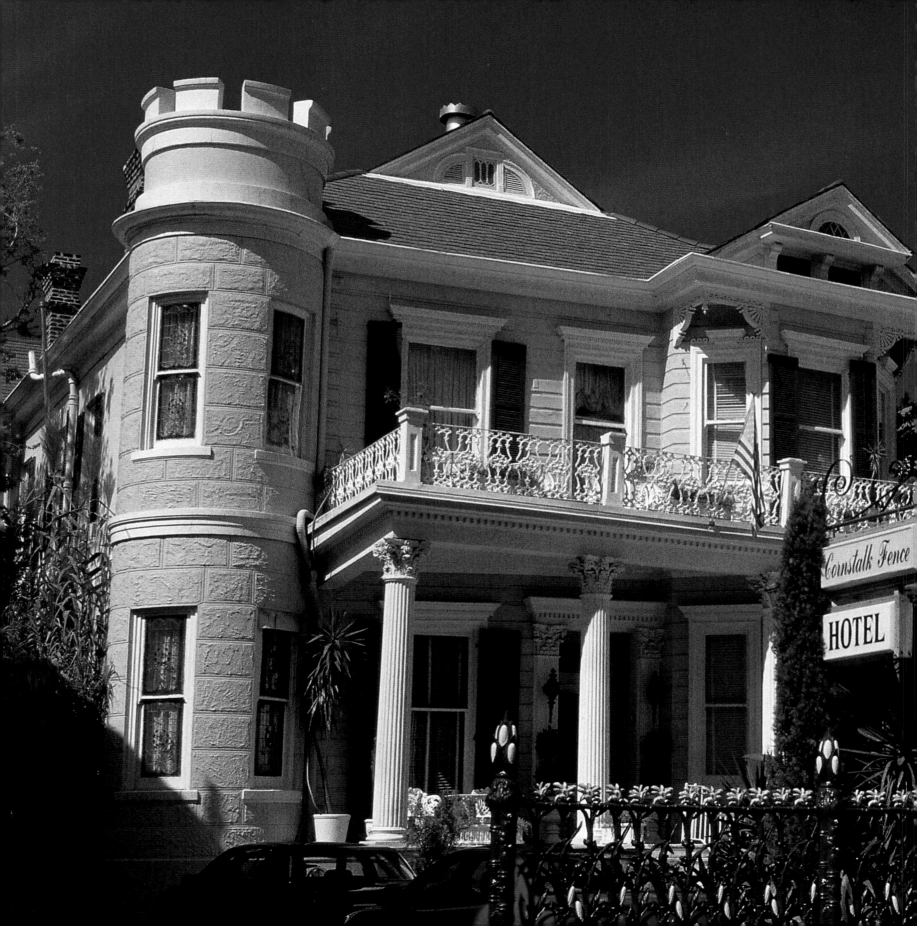

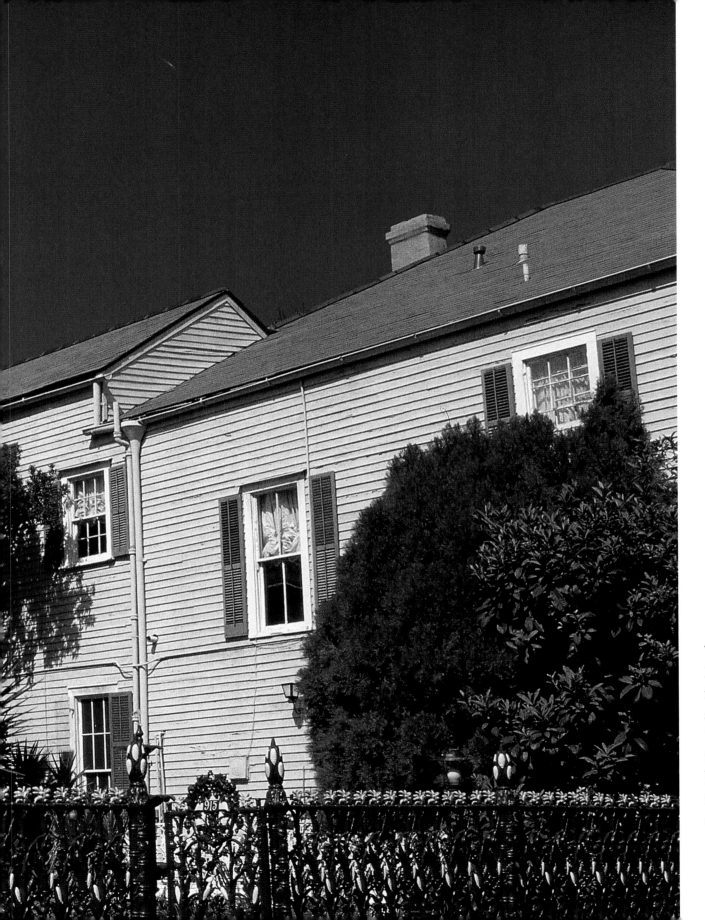

There are almost 30,000 hotel rooms in the metropolitan area. Along with 1,600 taxis, they cater to the thousands of business travelers and tourists who arrive each year.

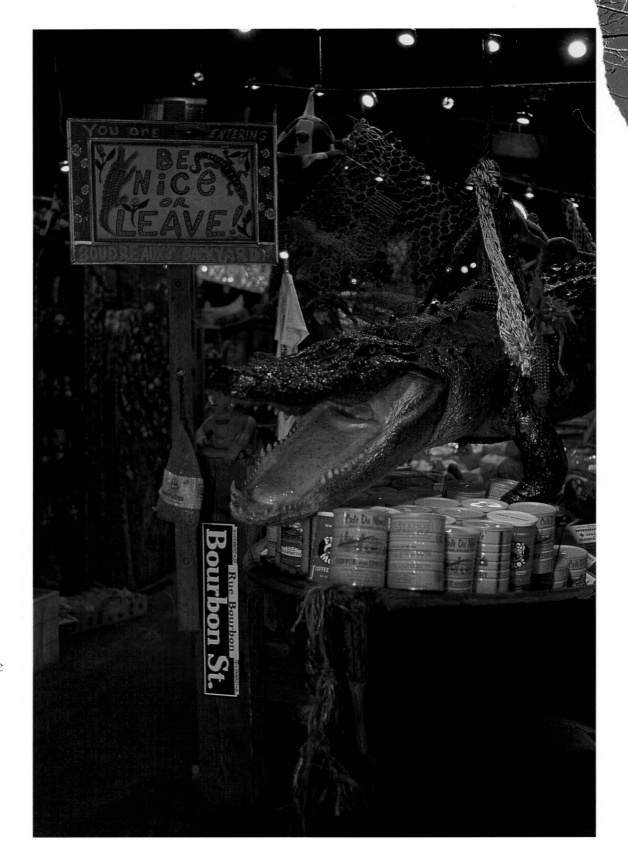

A county store specializes in "Cajun" souvenirs. While the Creole upper crust in New Orleans looked askance at manual labor, the Cajuns spurred the economy with farming and fishing, boat building and hunting.

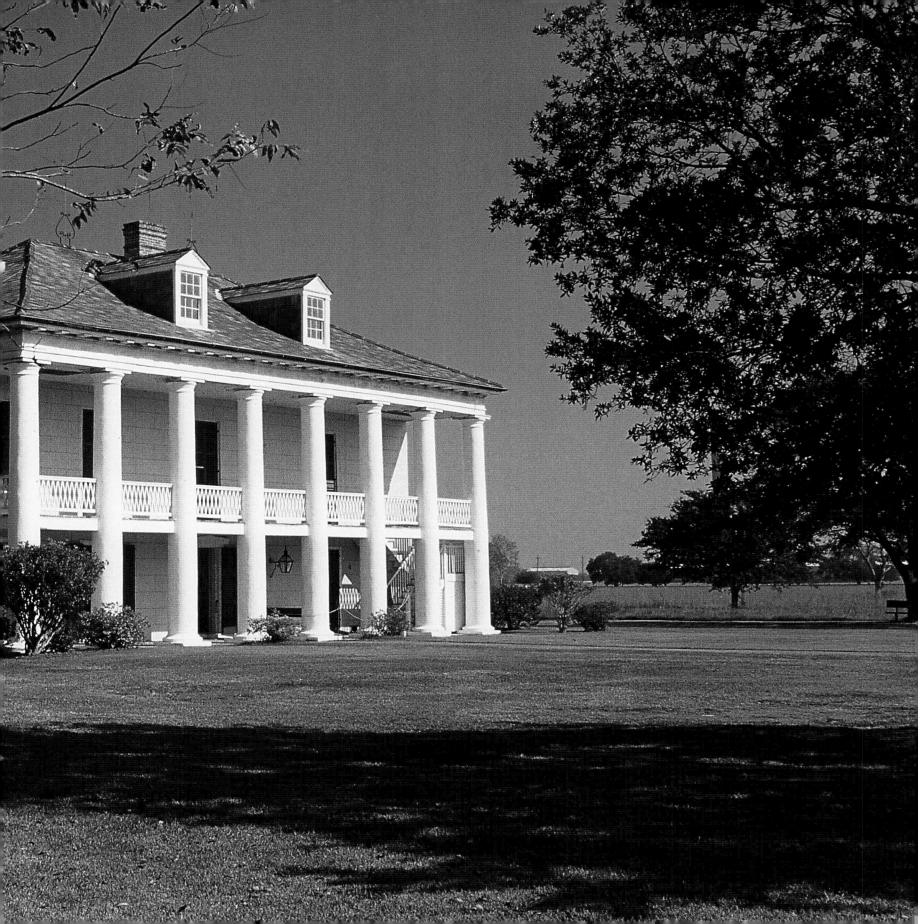

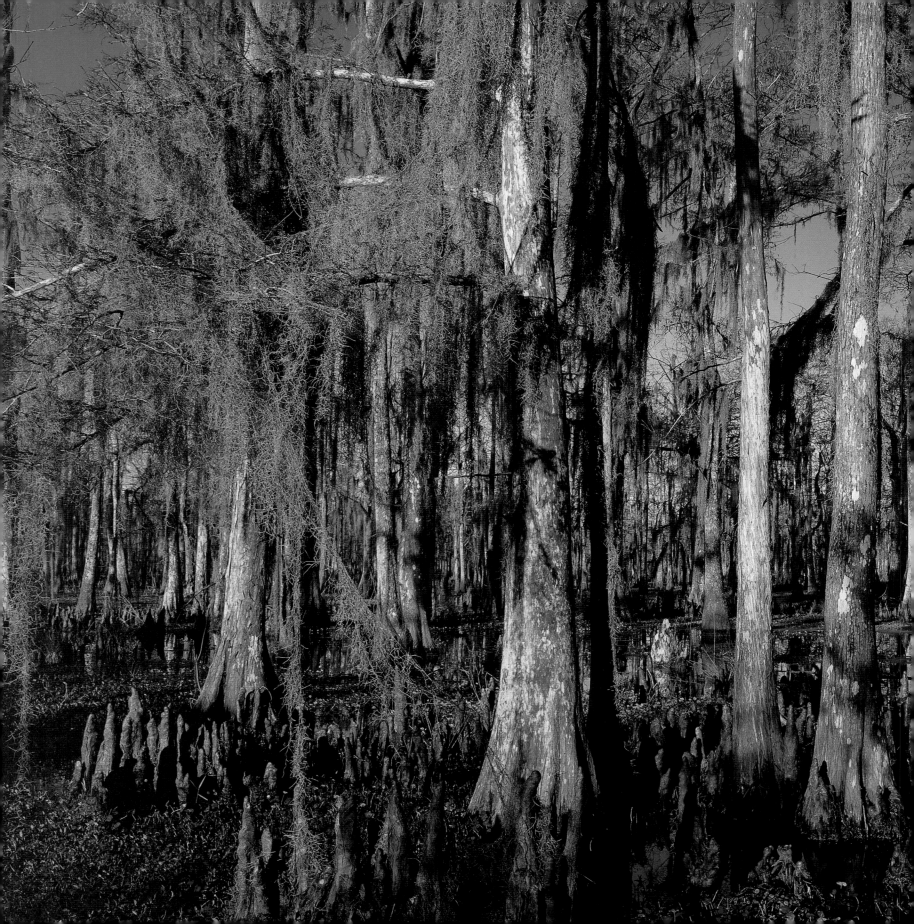

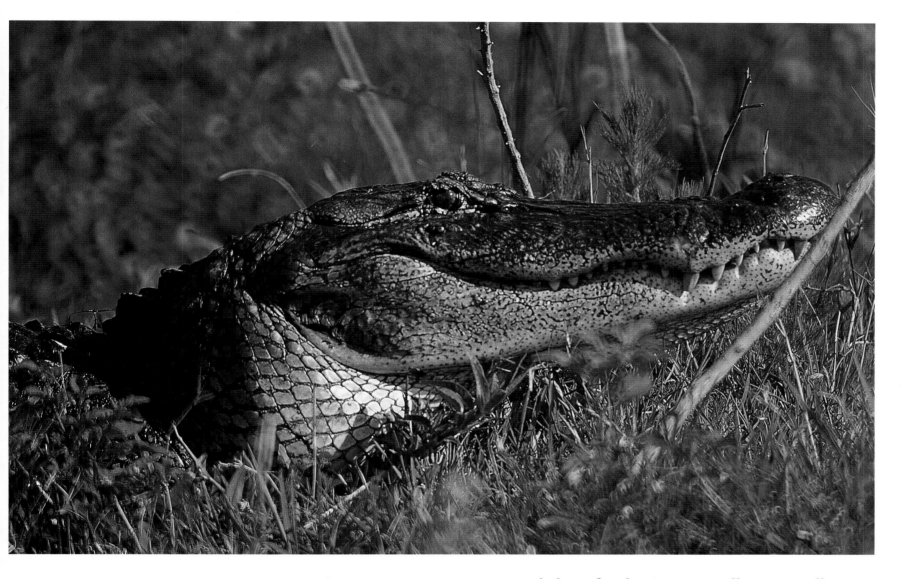

Louisiana swamps are prime habitat for the American alligator. Wallowing in the shallow waters, the reptiles create alligator holes—deeper ponds that are used as refuges by other water creatures during the dry season.

Preserving scenes typical of the Mississippi Delta, Jean Lafitte National Historical Park and Preserve helps visitors learn how the landscape and history of the region has influenced its culture.

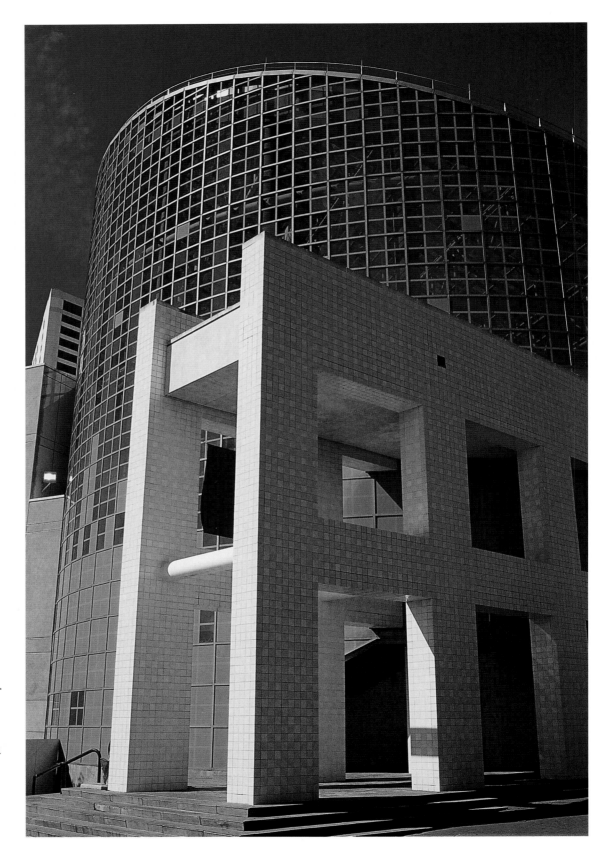

Inside the Aquarium of the Americas, visitors will discover aquatic habitats from around the world—the Caribbean Sea, the Amazon, the Gulf of Mexico, and more. The center houses more than 15,000 fish, reptiles, and birds, from the rare Louisiana paddlefish to the ubiquitous local alligators.

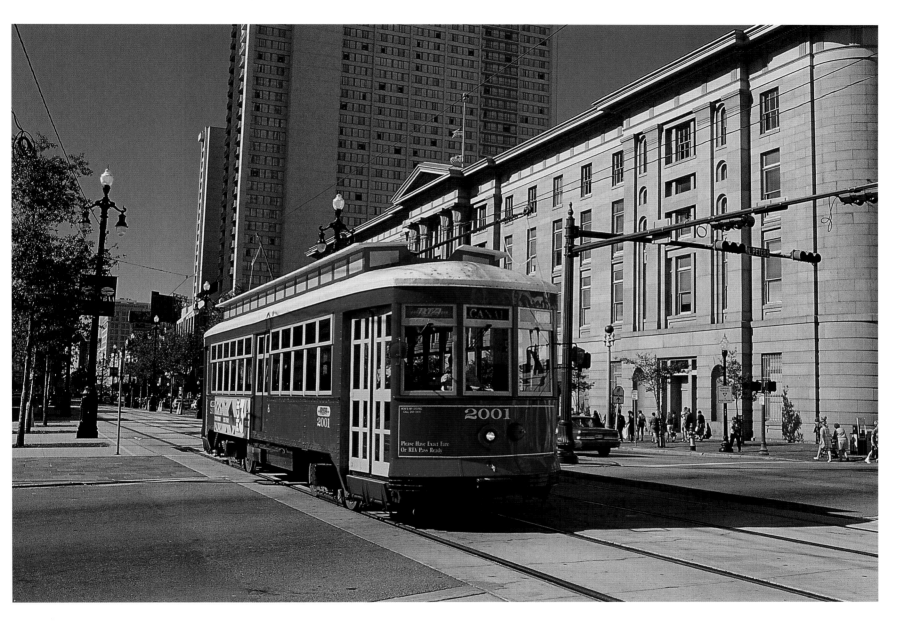

Visitors can ride one of New Orleans' historic streetcars for more than 13 miles from Canal Street to Carrollton. More than 150 years after the first route opened, this is still the only system of public transportation in the city.

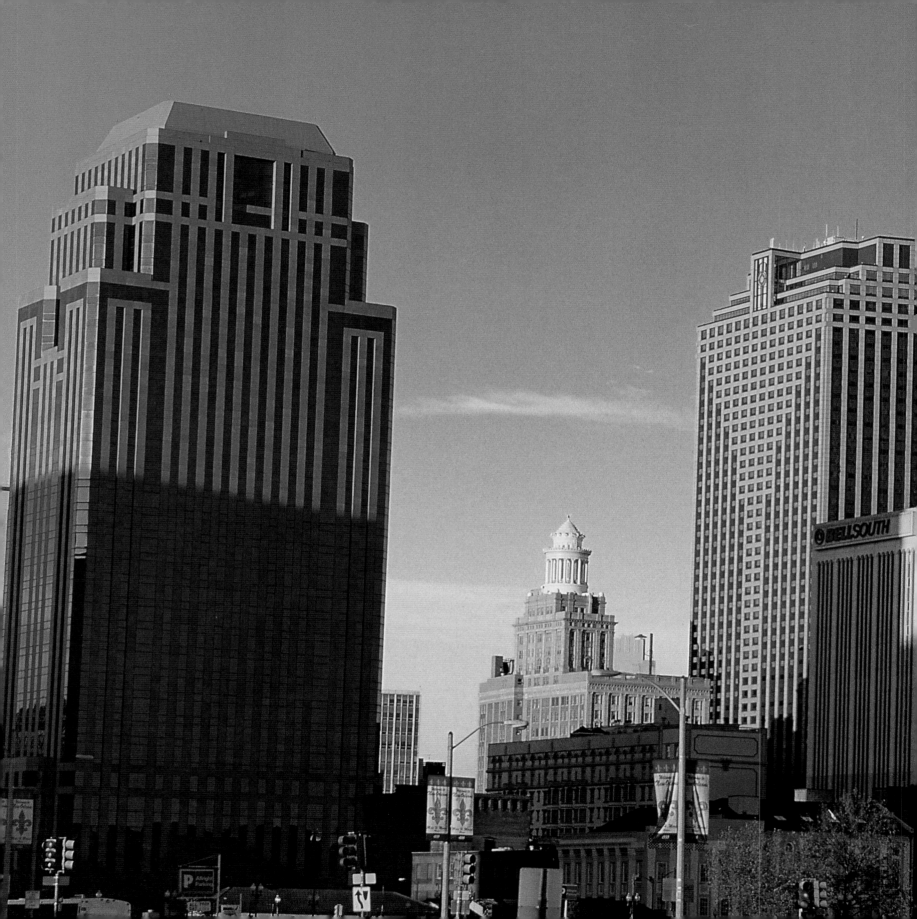

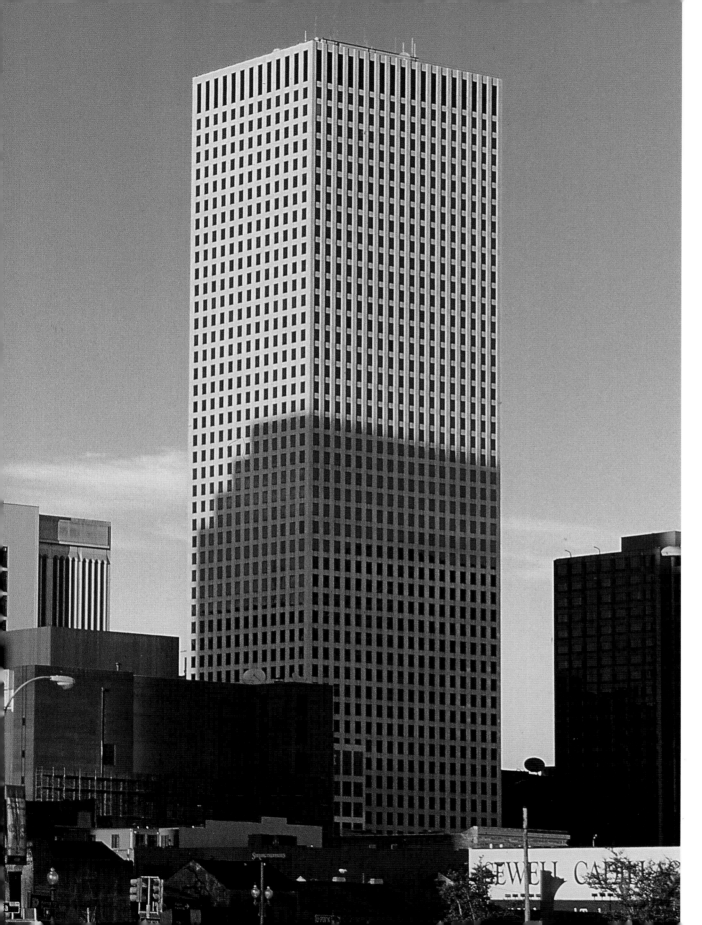

Extending between the Mississippi River and Claiborne Avenue, the Central Business District is a combination of stately office buildings from the nineteenth century and more modern structures, including some of the tallest buildings in the city.

61

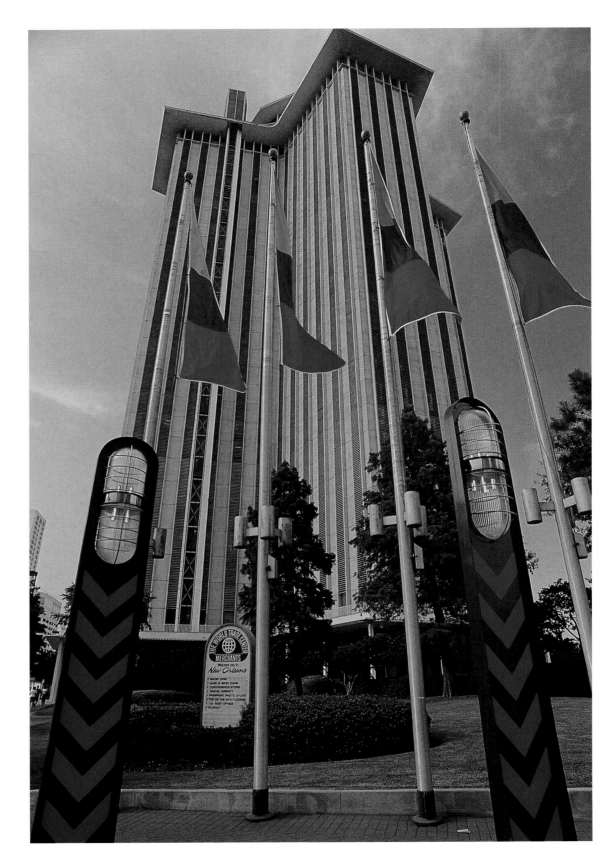

The first World Trade Center was built in New Orleans in 1943. There are now more than 320 of these centers in 95 countries, promoting business and trade between nations around the world.

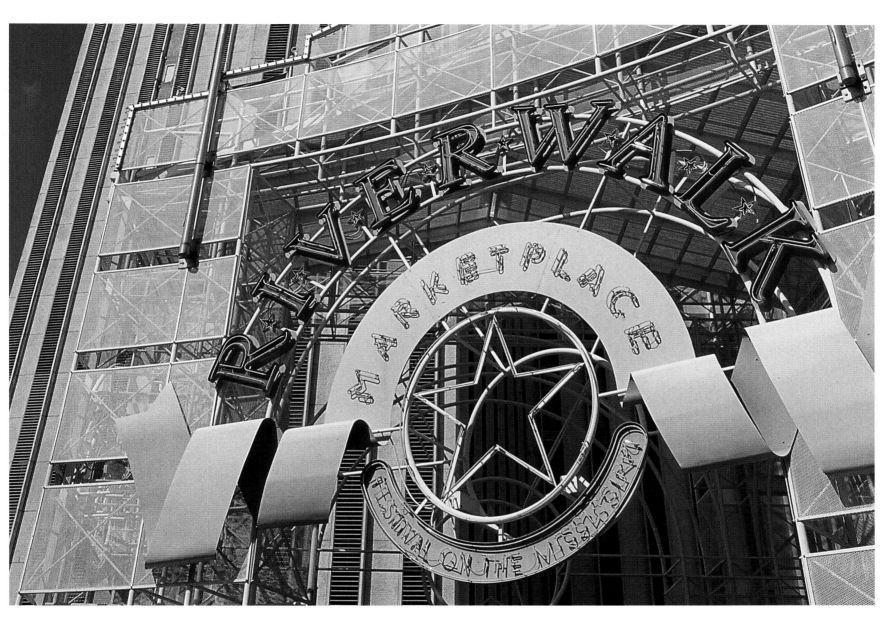

Just outside of the convention center, Riverwalk Marketplace draws shoppers with 120 stores, cafés, and street vendors.

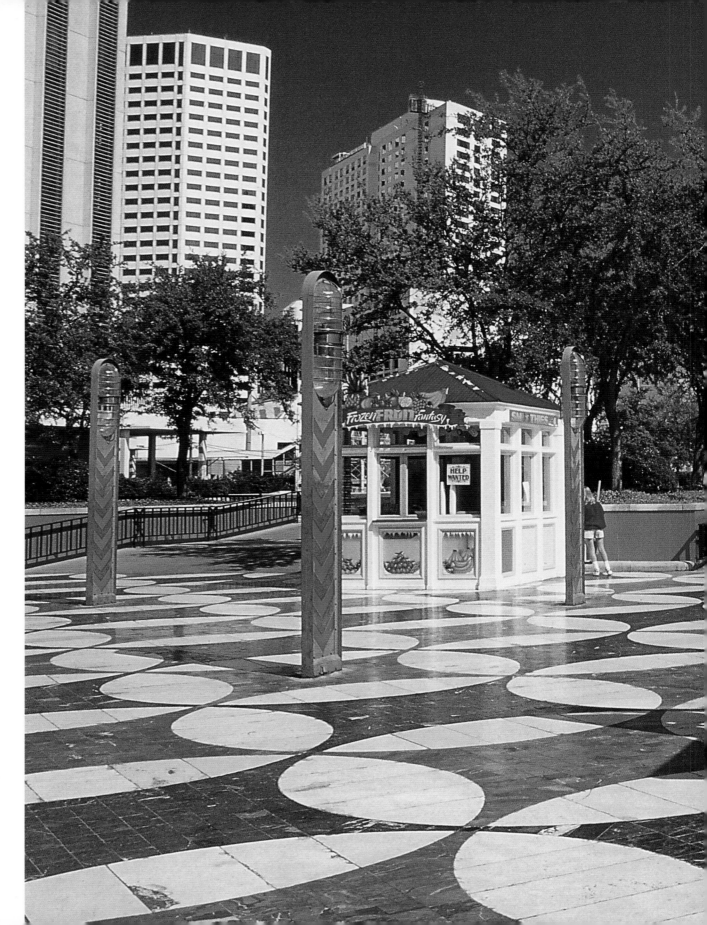

A sunny afternoon at Spanish Plaza will find shoppers escaping the bustle and resting their feet, music lovers enjoying an outdoor concert, or, at the right time of year, a host of Mardi Gras celebrations.

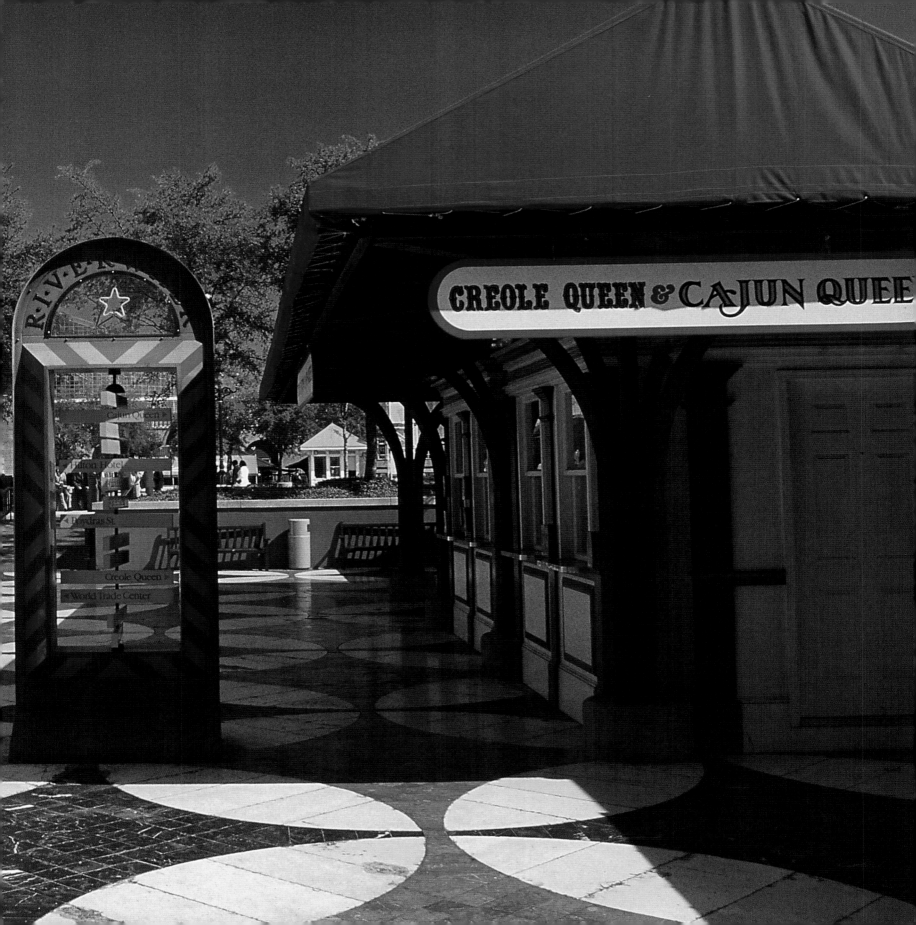

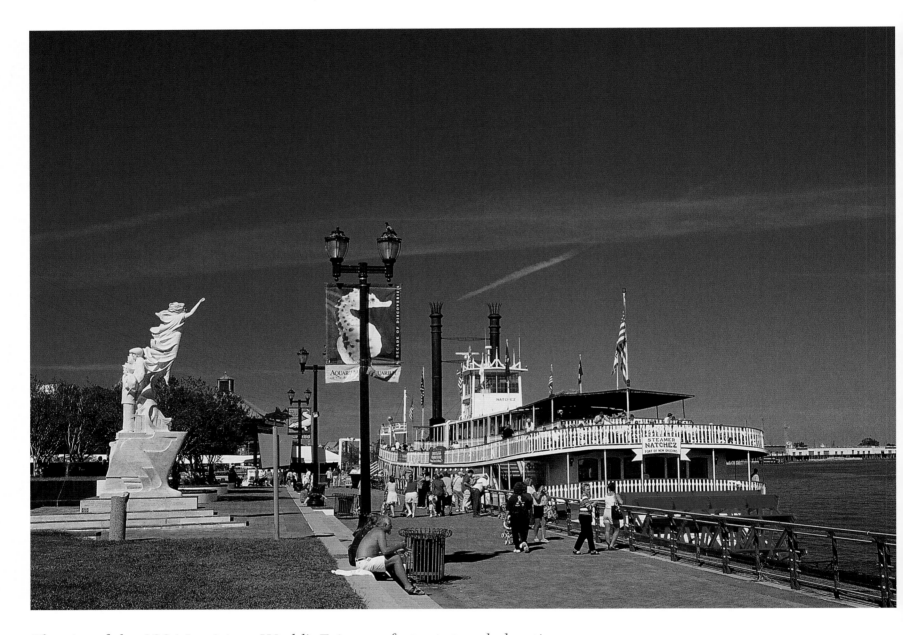

The site of the 1984 Louisiana World's Fair now features trendy boutiques and marketplace shopping, cafés and restaurants, a waterfront promenade, and more.

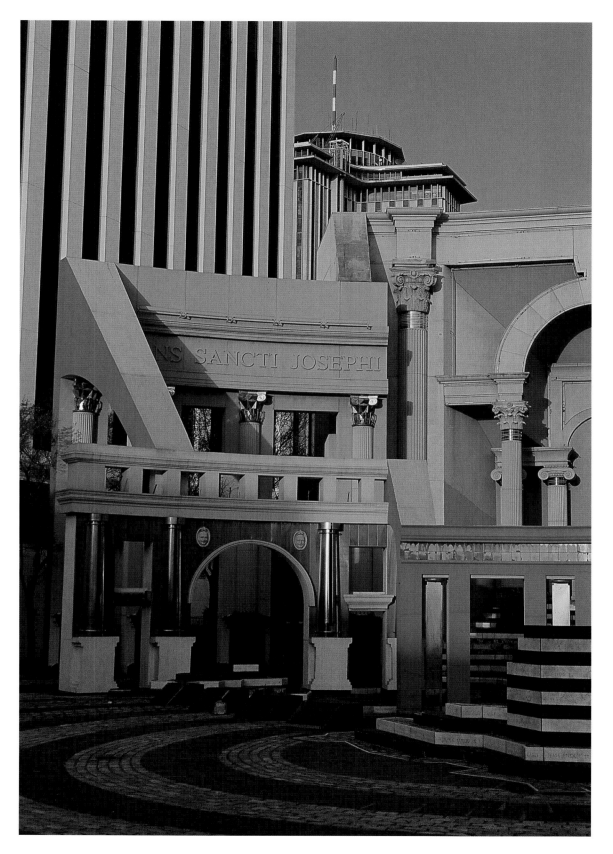

Wanting to recognize the contributions of Italian immigrants, the Italian community, the city, and a group of talented architects created the Piazza d'Italia in the late 1970s. The curving façades and colorful stonework invite visitors to wander through the unique creation.

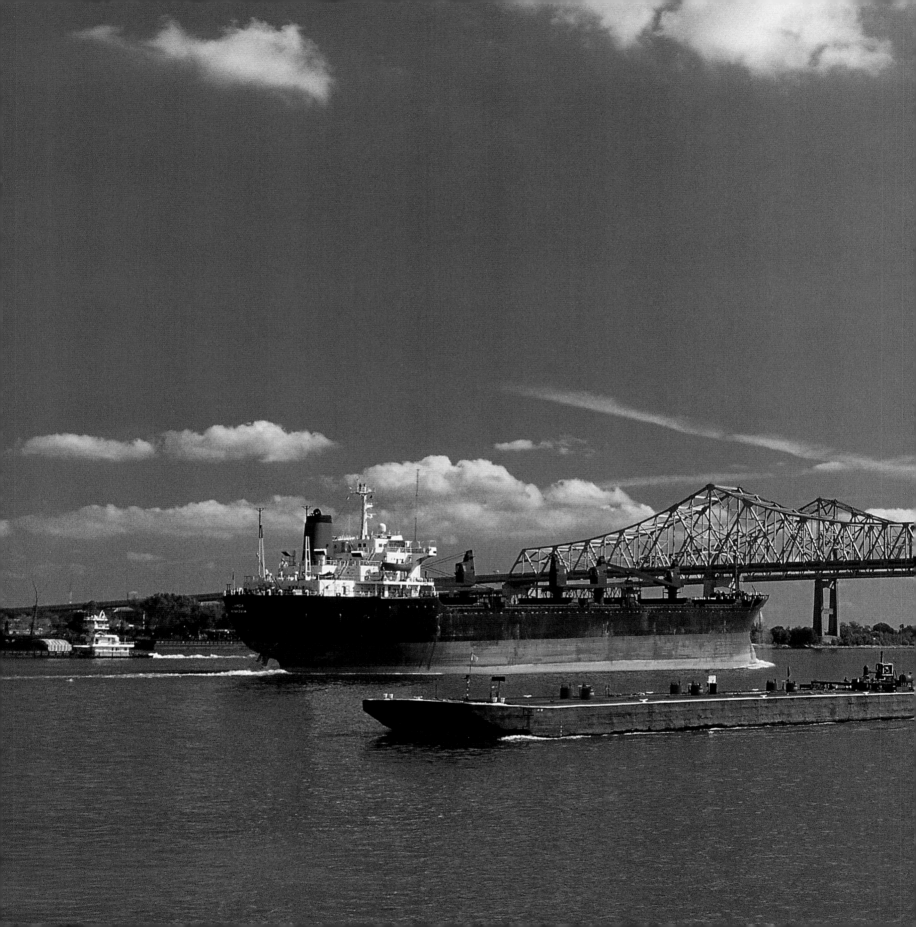

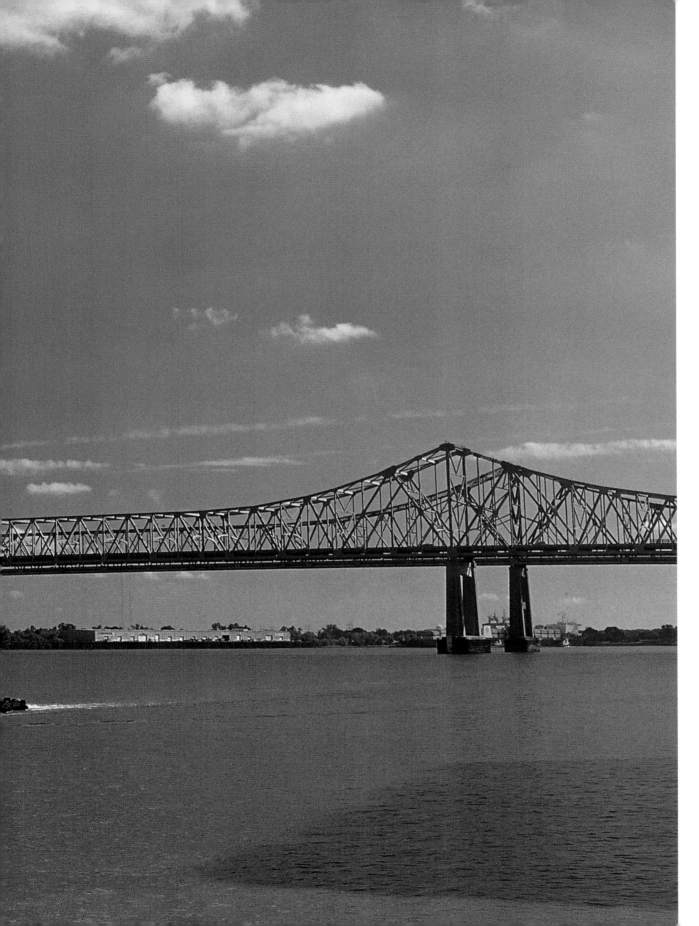

The Mississippi River flows past New Orleans, carrying 300 billion gallons of water per day. The present site of the city was formed by the river's silt deposits.

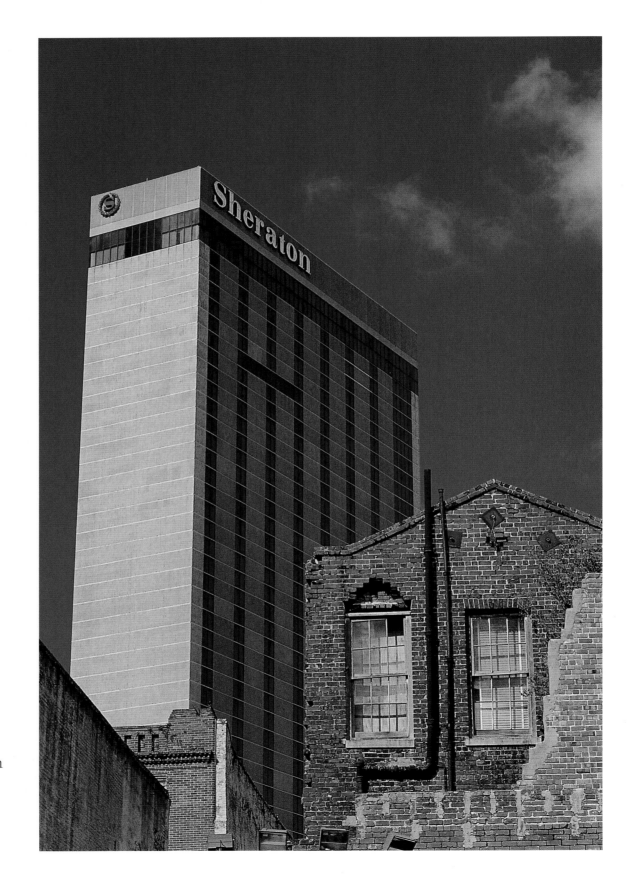

As commerce in New Orleans continues to grow, steel office towers and mirrored glass are juxtaposed with the historic mix of French, Spanish, and Italian architecture that has made the city renowned.

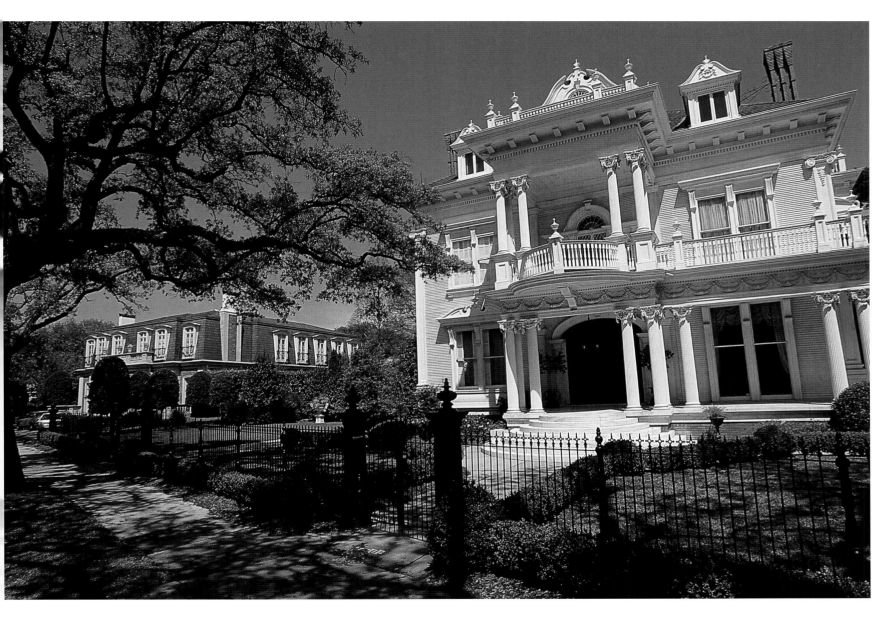

Richly embellished façades—some so elegant they resemble giant wedding cakes—are a standard feature on historic New Orleans homes. Columns and arches, ironwork and carvings decorate even middle-class neighborhoods.

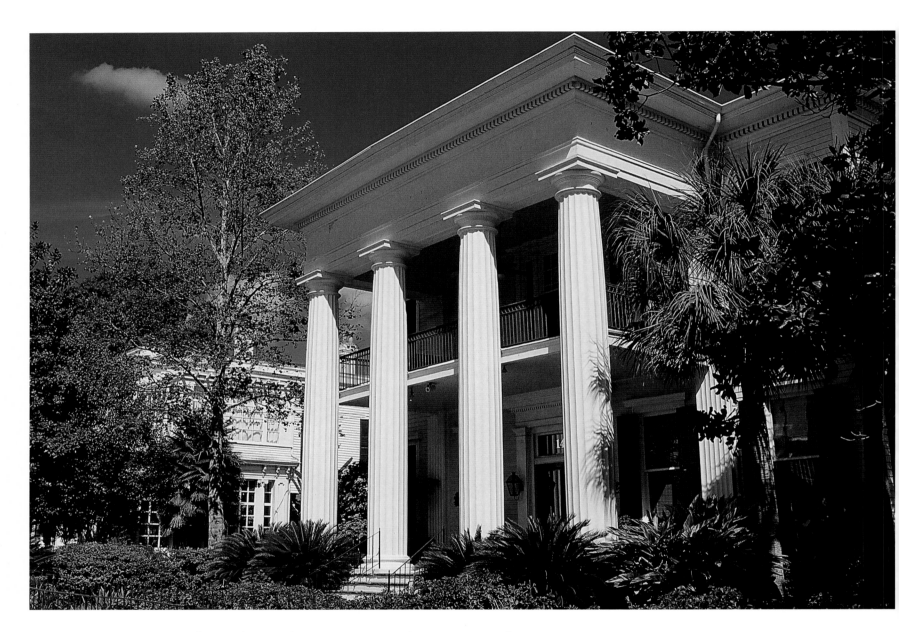

To protect themselves from the sweltering summer heat, New Orleans residents planted lush, tropical gardens around their mansions. Gigantic oaks wave over the pathways and banana leaves unfurl along the walls.

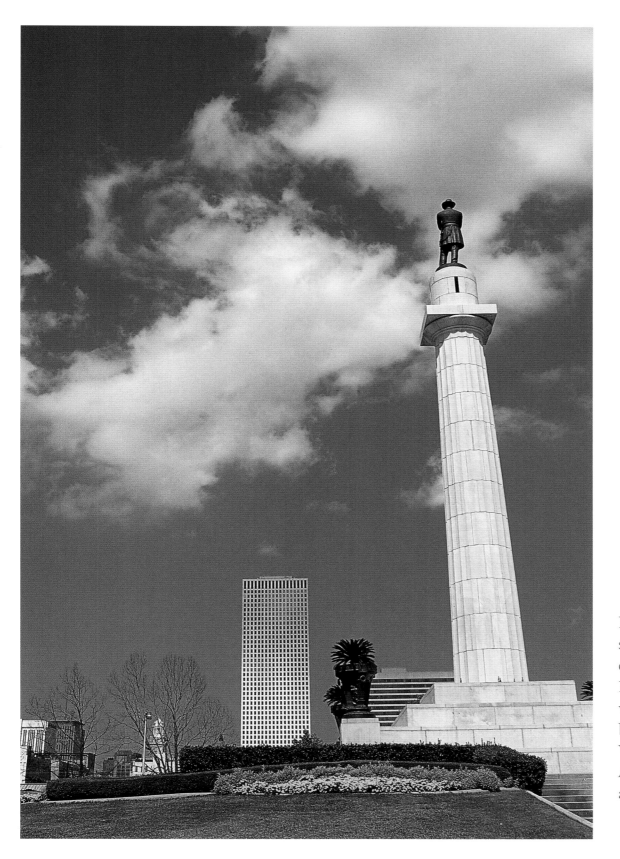

Robert E. Lee is the stoic figure on the column in Lee Circle. Lee was a general who won respect from both sides in the Civil War. A monument in Arlington, Virginia, also bears his name.

Rising 280 feet above the floor, the roof of the Louisiana Superdome has a radius of 600 feet. Up to 72,000 people gather here for basketball and football games, conventions, and concerts.

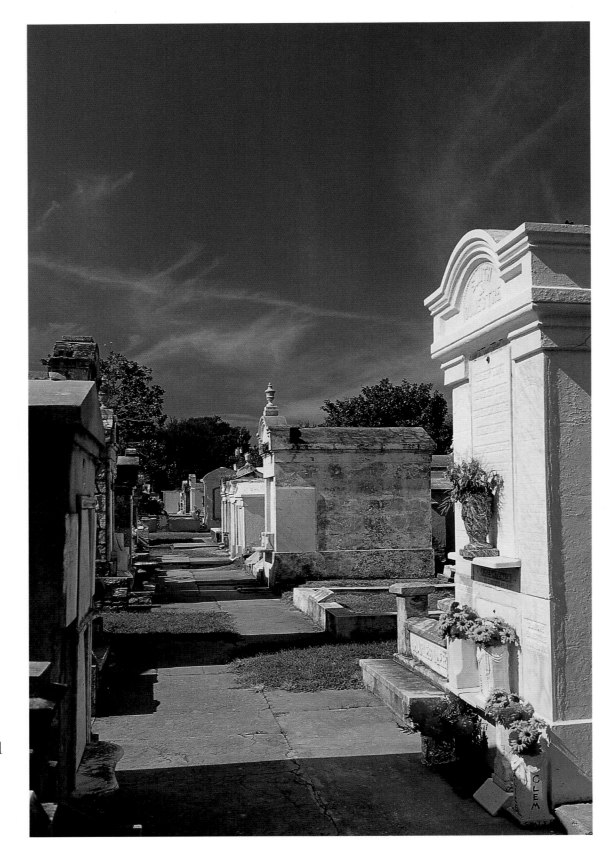

The frequent floods in New Orleans had an unfortunate effect on the dead—buried coffins floated to the surface. In response, people began to build elaborate, above-ground tombs such as these family vaults in Lafayette Cemetery.

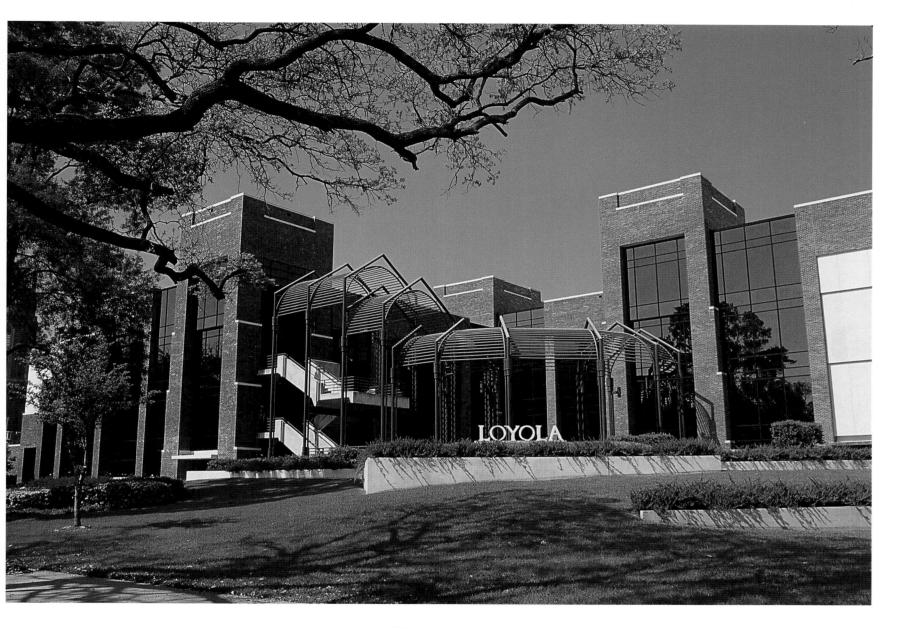

Although open to students of all faiths, Loyola University is based on a Jesuit tradition of education. Over 5,000 students from 50 states and more than 45 countries attend classes here.

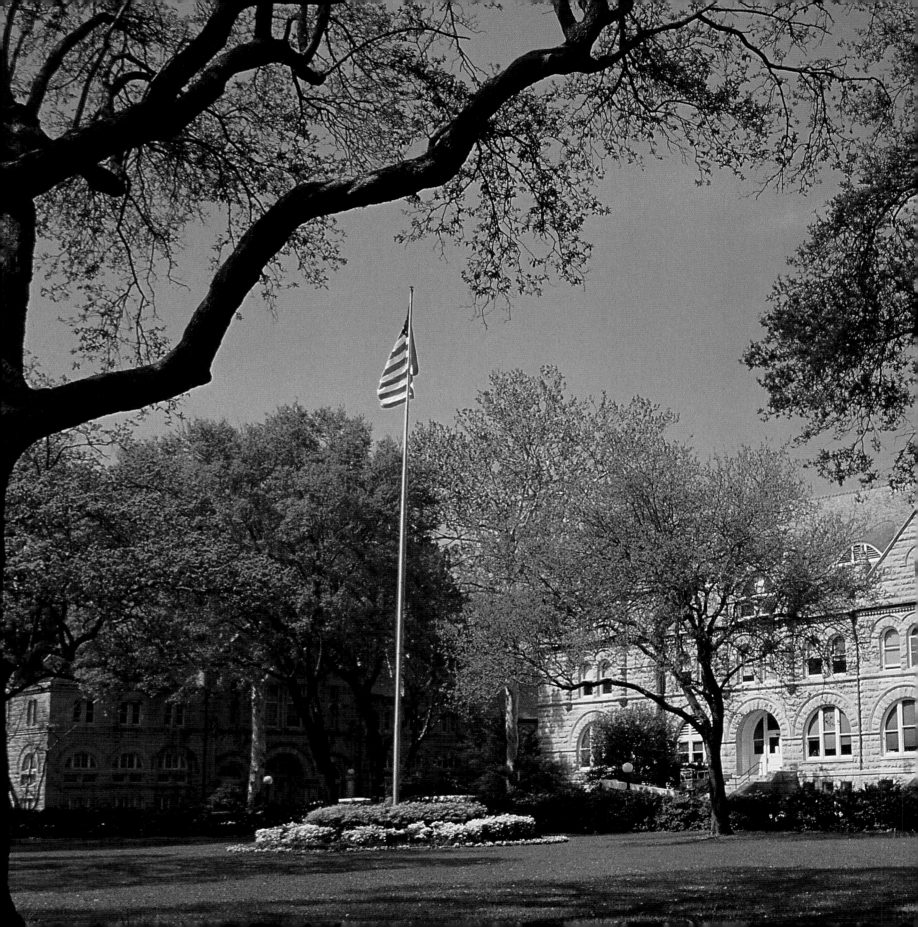

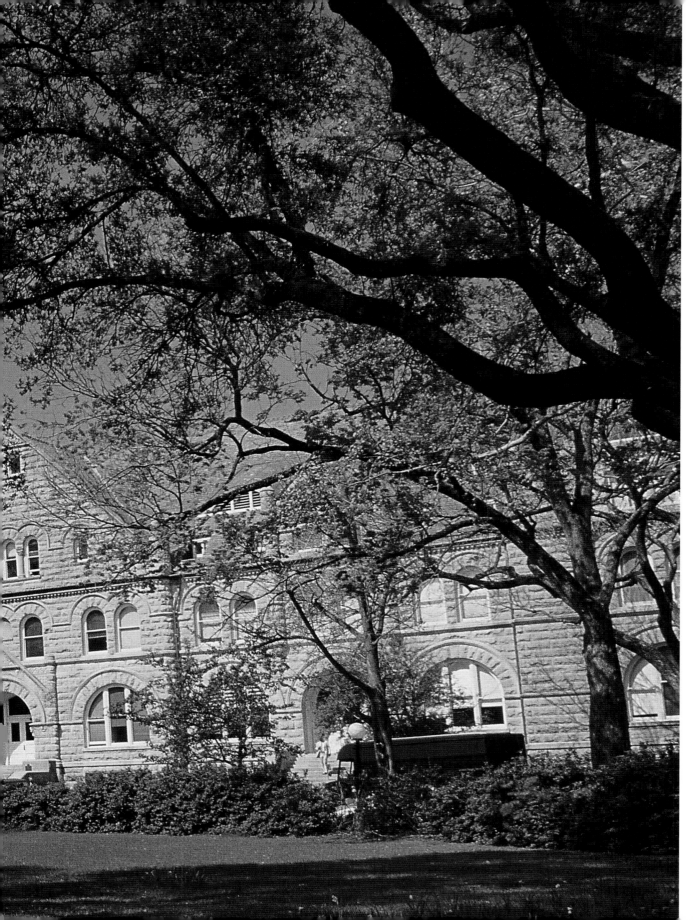

Just steps away from Loyola, Tulane University was founded in 1884 and caters to more than 7,000 undergraduate students in more than 1,300 programs. The school is known for its medicine and law programs, as well as its research findings.

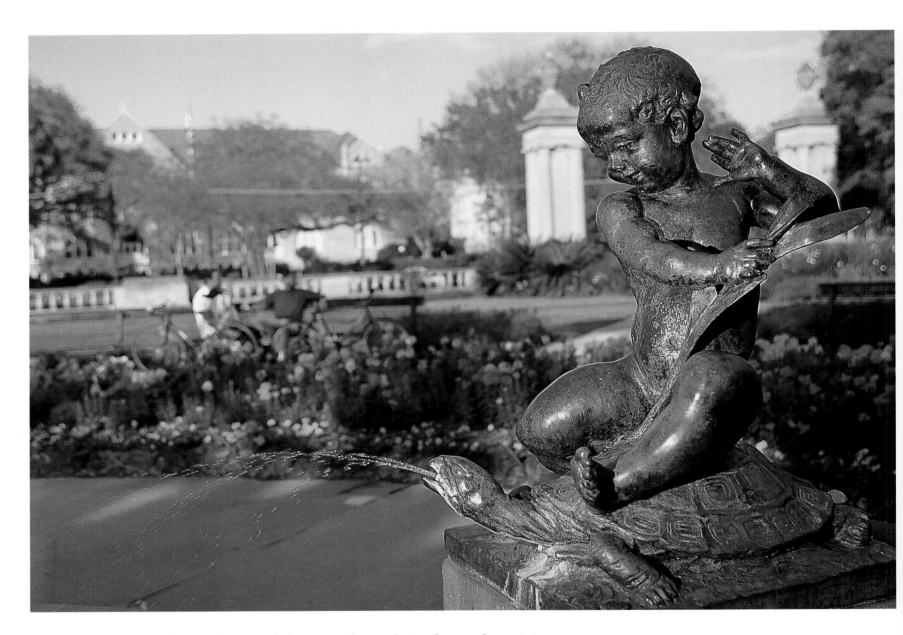

Each new turn in the path at Audubon Zoological Gardens takes visitors to a new environment—the Asian Domain, the African Savanna, the Australian Outback, or the Louisiana Swamp.

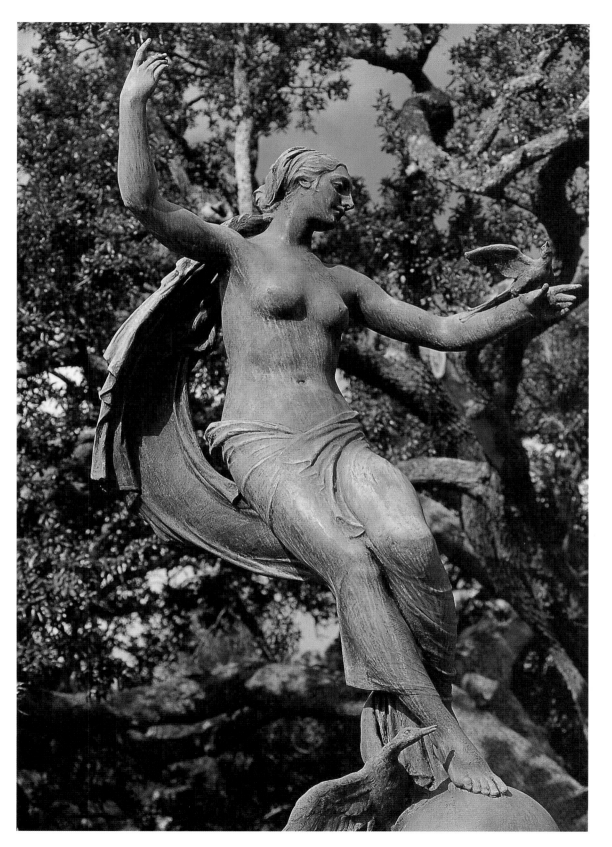

The creatures at Audubon Zoological Gardens roam habitats much like those in their native countries. Lush tropical plants flourish in some regions, while desert sand carpets others.

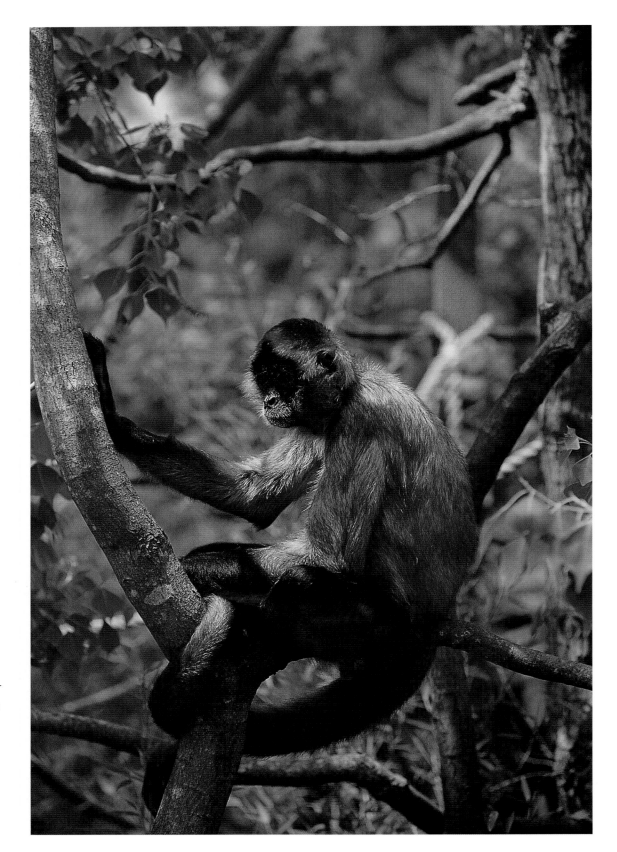

Sightseers at Audubon Zoological Gardens might come face to face with a mischievous monkey, a Komodo dragon, a zebra, or a jaguar. With more than 1,500 animals, this is one of the top zoos in the nation.

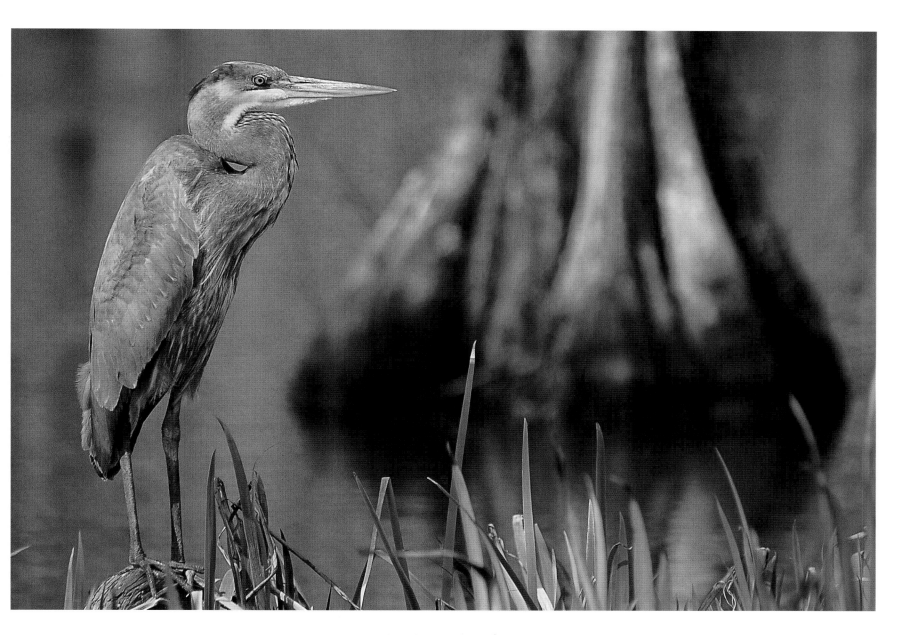

A great blue heron has found a quiet spot to fish on Cypress Lake. Along with countless bird species, the swamps and bayous of the region are home to swamp rabbits, endangered gopher tortoises, and alligators.

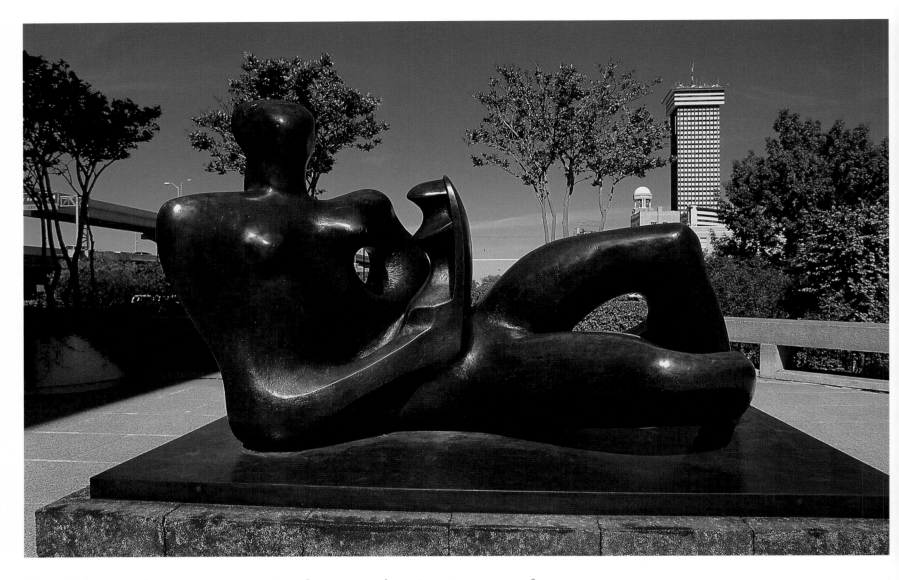

New Orleans is home to more artists than any other American city of its size. Thanks to the creations of painters and sculptors, popular writers such as Anne Rice, and musicians such as Harry Connick Jr., the city's art scene is constantly changing.

Built in 1956, the 24-mile causeway across Lake Pontchartrain to New Orleans is one of the longest in the world.

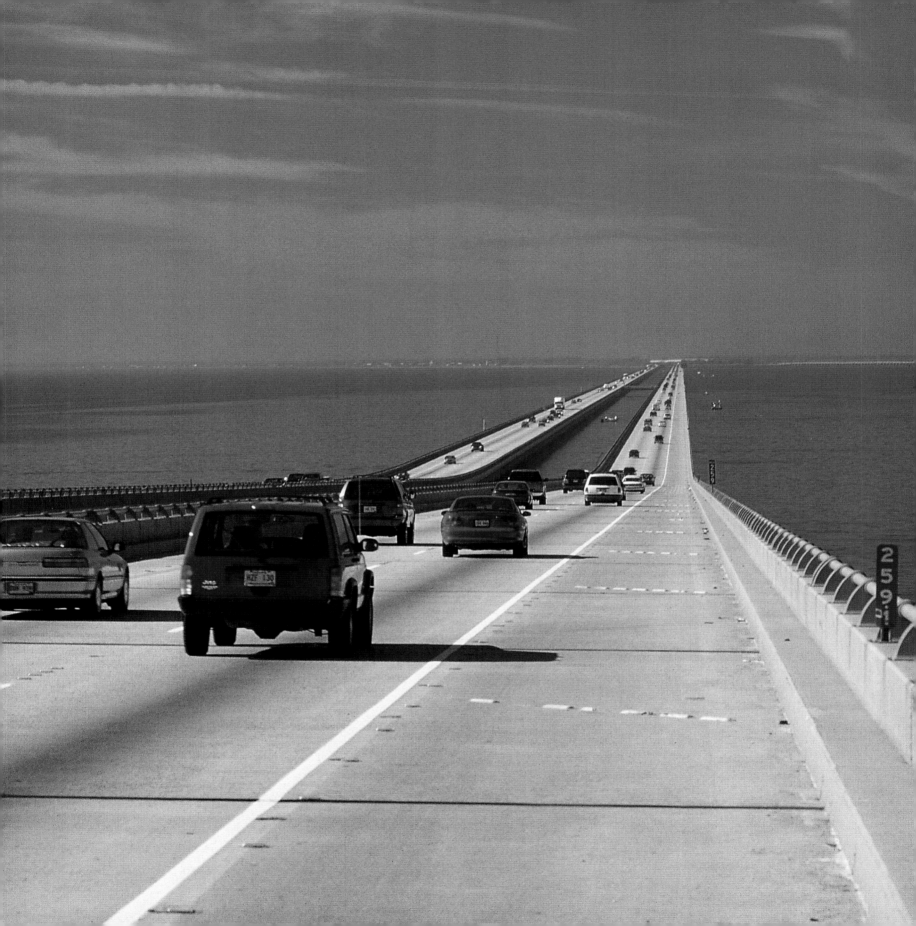

The New Orleans
Museum of Art was
founded in 1910
when Jamaican immi-
grant and plantation
owner Isaac Delgado
presented the city's
parks commission
with a donation of
$150,000. Today, the
museum boasts 46
galleries and more
than 40,000 works.

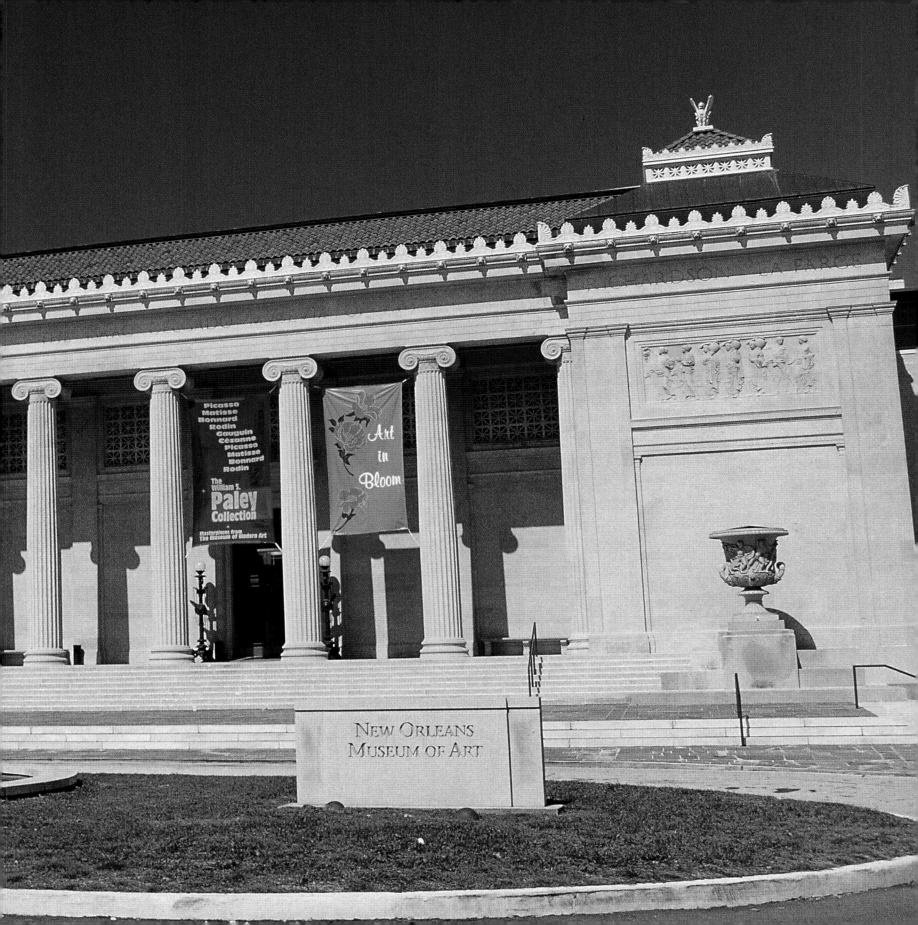

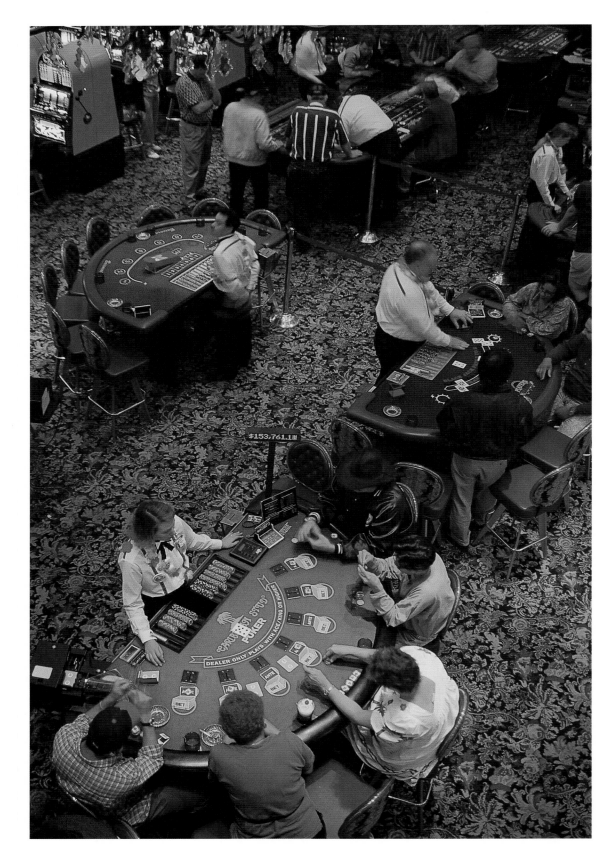

Visitors can test their luck at several New Orleans casinos, where the atmosphere is year-round Mardi Gras. The Big Easy—originally a jazz term—takes on a whole new meaning.

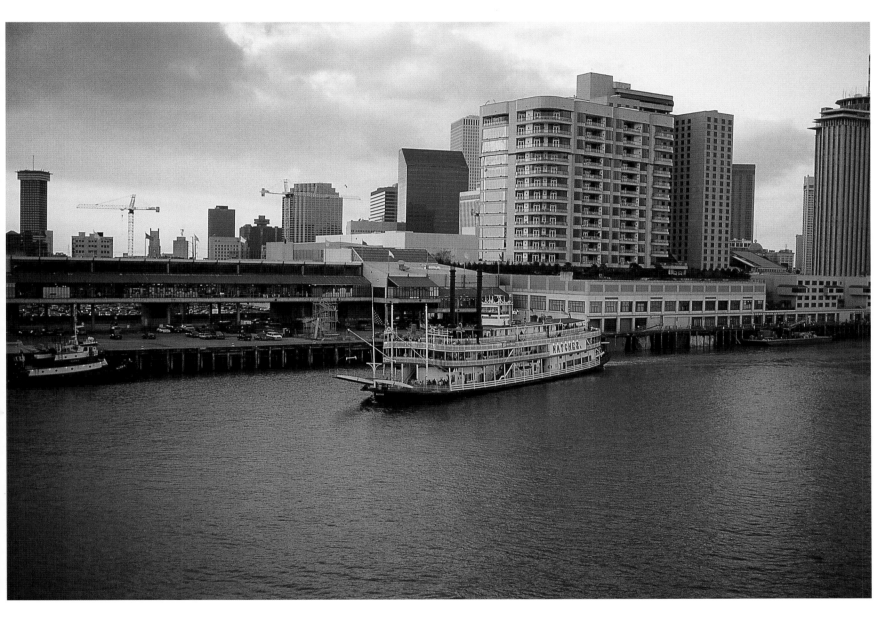

New Orleans gets its nickname—Crescent City—from the way the Mississippi River curls past the metropolis. On the other side, the streets border Lake Pontchartrain, the seventh-largest lake in the United States.

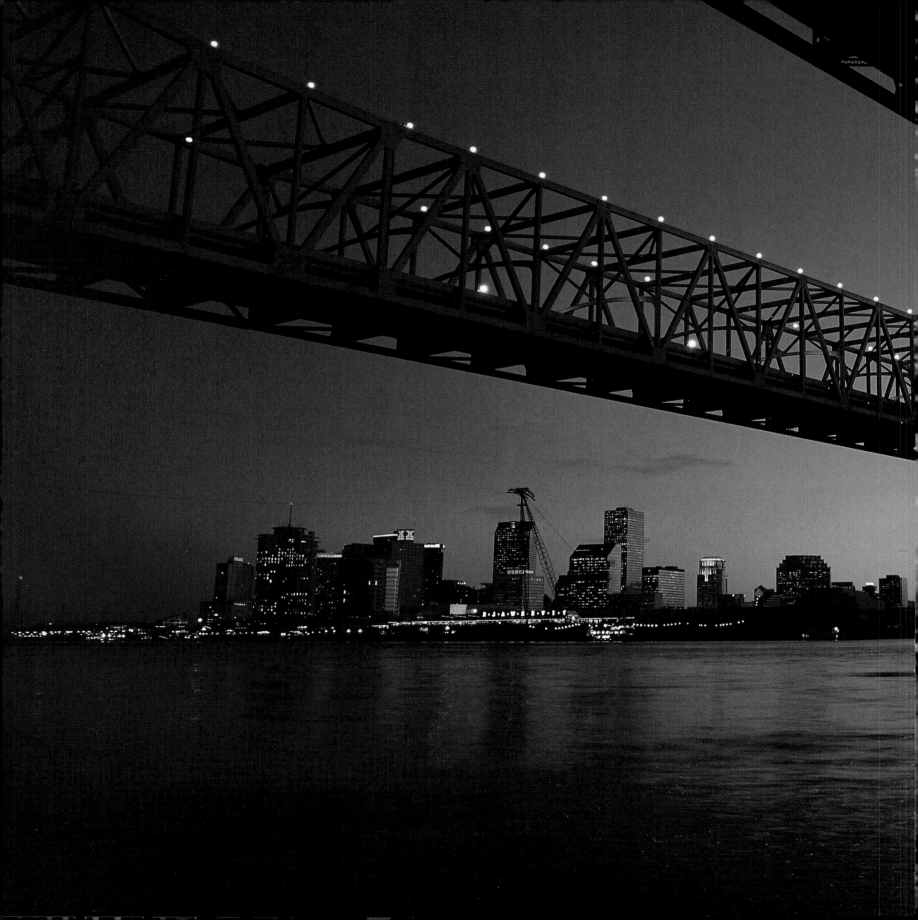

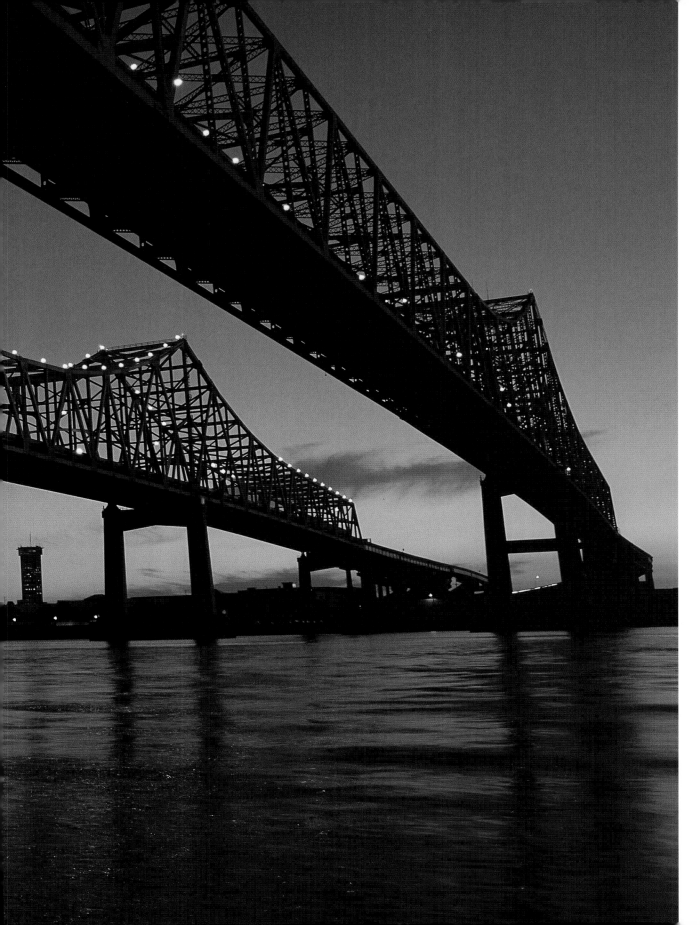

The first bridge across the Mississippi River was built in 1935. Before that time, the winding river and the massive lake across from it effectively isolated the city.

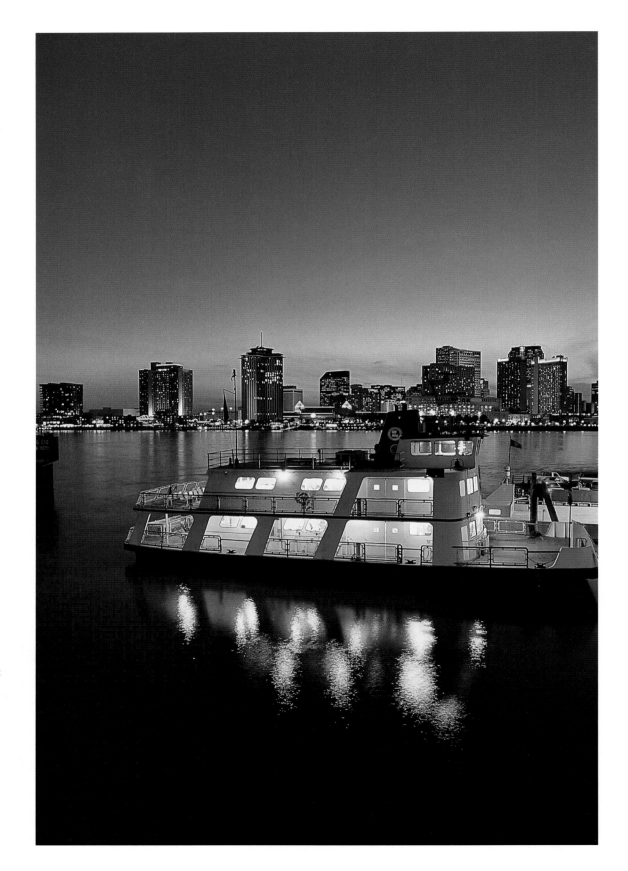

Along with the French Quarter, Algiers Point is one of the city's oldest neighbor-hoods. This is the home of New Orleans' shipbuilding past—the historic home of riverboat captains and merchants.

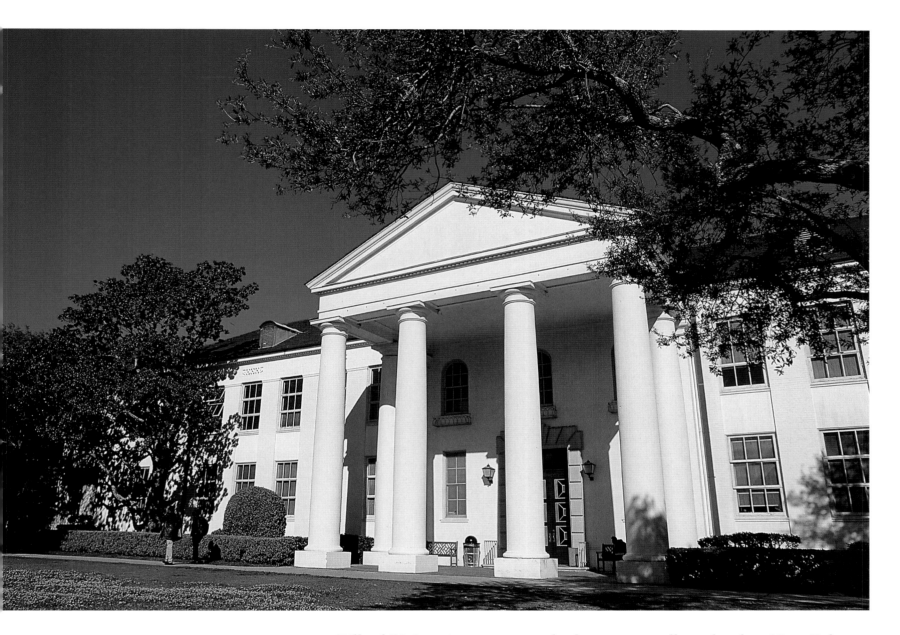

Dillard University was created when two smaller schools—New Orleans University and Straight College—merged in 1930. The new school was named for James Hardy Dillard, a pioneer of education for African Americans in the southern United States.

Just outside New Orleans along the Mississippi River, Oak Alley Plantation is one of the most beautiful in the state. Three-hundred-year-old oaks shelter the route to the 1839 mansion, built by French Creole plantation owner Jacques Telesphore Roman, as a gift to his new bride.

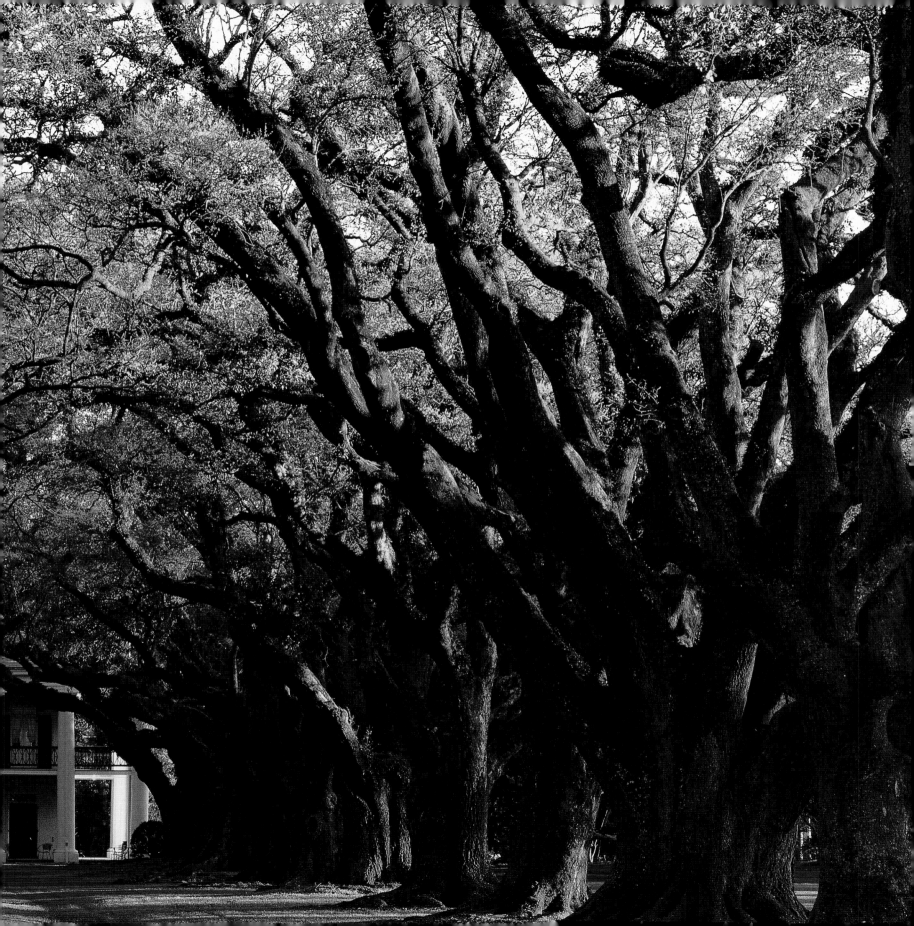

Photo Credits

W. Cody/First Light 1, 3, 9, 90–91

James Lemass/Folio Inc. 6–7, 8, 14, 20, 22–23, 28, 32, 43, 45, 60–61, 67, 71, 74–75, 80, 84, 92, 93

Michael Ventura 10, 81

Richard Nowitz/Photri Inc. 11

Jeff Greenberg/Photri Inc. 12–13, 19, 30–31, 40, 41, 88

Jürgen Vogt 15, 16–17, 18, 21, 25, 26–27, 48, 49, 50–51, 52, 58, 59, 63, 66, 68–69, 70, 72, 73, 76, 85

Andrews/Photri Inc. 24

Audrey Gibson/Photri Inc. 29

John M. Roberts/First Light 34–35

Scott Bern/Photri Inc. 33

Jeff Greenberg/Unicorn Stock Photos 36, 37, 38–39, 46–47, 83

Andre Jenny/Unicorn Stock Photos 42, 44, 54–55, 64–65, 86–87

Tom Till 56, 94

Chuck Schmeiser/Unicorn Stock Photos 53

Arthur Gurmankin & Mary Morina/Unicorn Stock Photos 62

Jean Higgins/Unicorn Stock Photos 77, 78

James P. Rowan 82

Jack Novak/Photri Inc. 89

Tom Edwards/Unicorn Stock Photos 57